DIRECTOR'S CHOICE
THE ABBEY LIBRARY
OF ST GALLEN

Locus
foci

ingressus

mensae

caminata

formarum

ceces parua

caminata portarum

Scriba hic hospit
uel templi littere
subibit

Discentas scolae
pulchra iuuenta
simul

ian nes

colum nare

COLVM NIS

culina hospitum

pistrinum

fornax

Insistendae pastae locus

DIRECTOR'S CHOICE

THE ABBEY LIBRARY OF ST GALLEN

Cornel Dora
Philipp Lenz
Franziska Schnoor

SCALA

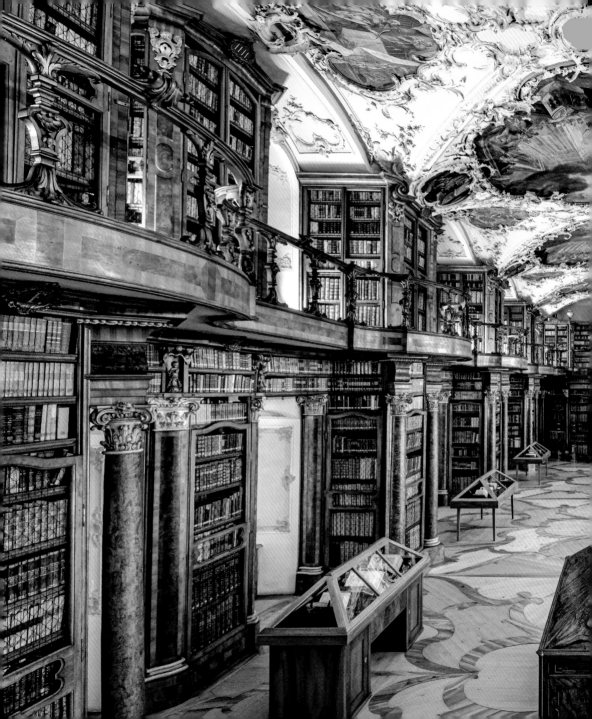

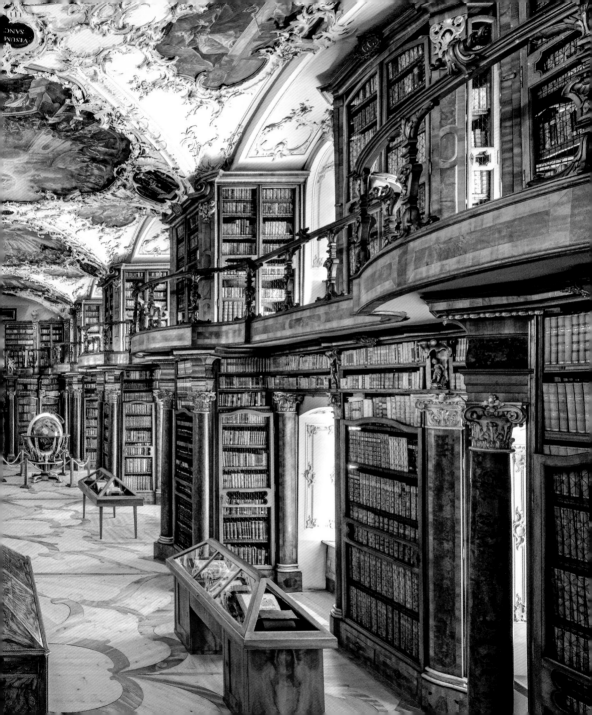

FOREWORD

THE ABBEY LIBRARY OF ST GALLEN was not founded as such, but came into being over several centuries. Beginning with the arrival of the Irish monk Gall (also known by the Latinised name of Gallus) at the river Steinach in 612 AD, it took shape gradually and became permanently established in the ninth century as an important part of the infrastructure of one of the leading monastic communities in Europe. It survived with highs and lows over the centuries until the dissolution of the Benedictine monastery in 1805. Today it is run by the democratic lay organisation of the Roman Catholics of the Canton of St Gallen as an academic library that is highly valued by researchers.

Because of its age and its stock of early medieval manuscripts, which have survived in a uniquely complete state of preservation and were for the most part produced in the Abbey's own scriptorium, the library is one of the most important historical collections in the world. It represents over 1,200 years of uninterrupted activity.

This miraculous work of history, endowed with the most beautiful library hall imagin-able, forms the core of the Abbey District of St Gallen, which was added to the UNESCO list of World Heritage sites in 1983. Together with the store of documents and records in the Abbey Archive, its historical collection of books from before 1805 was also listed in UNESCO's Memory of the World Register in 2017. No other community of people from the eighth to the eleventh century is better substantiated in written sources than that of the monks of the Abbey of St Gall.

In this overview, the management team of the Abbey Library presents a personal selection of the most important items from the book collection, as well as a few other objects in and around the library that are worth seeing.

Cornel Dora, Director of the Abbey Library

Gregory the Great – ceiling painting in the Baroque Hall of the Abbey Library.

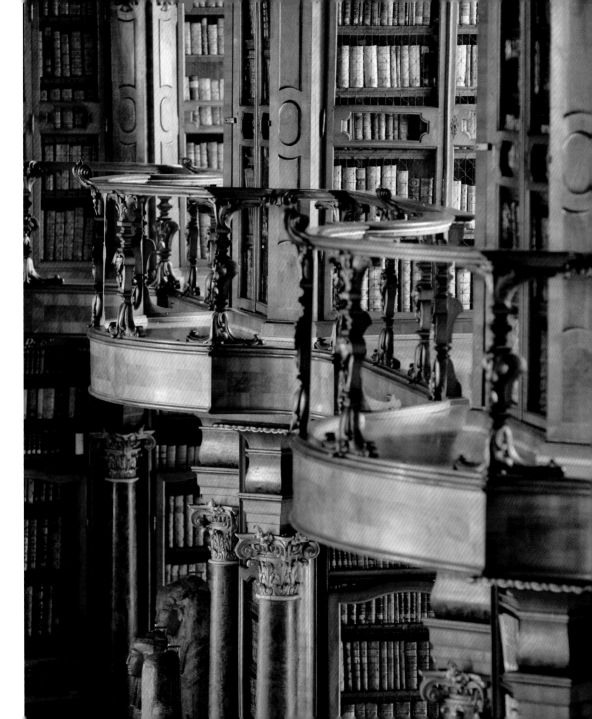

The healing-place of the soul

FRANZ ANTON DIRR, 1781
ΨΥΧΗΣ ΙΑΤΡΕΙΟΝ (Psyches Iatreion)
Library entrance with supraporte

ON THE BAROQUE OVERDOOR above the magnificent entrance to the Abbey Library of St Gallen is the Greek inscription ΨΥΧΗΣ ΙΑΤΡΕΙΟΝ (Psyches Iatreion), which has developed into our modern word 'psychiatry'. The most usual English translation is 'healing-place of the soul', but it can also be rendered slightly more freely as 'pharmacy of the soul'. Just as we select medicines from the shelves in the pharmacy in order to restore our bodies to health, here we take books from the shelves in order to heal our souls. The idea of healing is associated with the culture of reading and knowledge, and also with our spiritual being.

The motto inscribed on the panel was probably taken from an early baroque treatise on libraries by Claude Clément. However, it goes further back to the ancient Greek author of a universal history Diodorus Siculus (first half of first century BC), who reported in his *Bibliotheca Historica* (Historical Library) that this saying – presumably in the Egyptian language – was mounted above the temple library of the great pharaoh Rameses II (1303–1213 BC) near Thebes. This inscription is found not only in St Gallen but also in a number of other places, for instance in the baroque libraries of Uppsala, Vienna and Modena.

The healing power of books is particularly noticeable in this delightful place and it is sensually celebrated and reinforced throughout the uniquely beautiful baroque Library Hall to which the portal gives access.

Cornel Dora

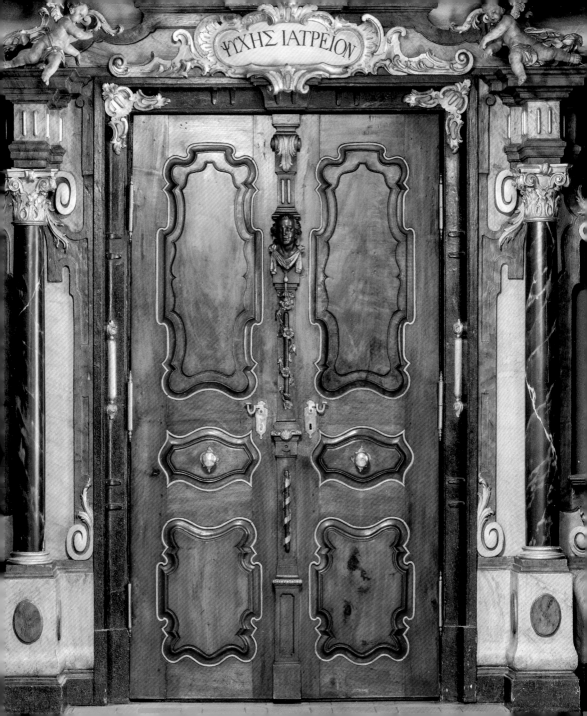
ΨΥΧΗΣ ΙΑΤΡΕΙΟΝ

Virgil in capitalis quadrata characters – the Vergilius Sangallensis

Rome (?), 5th century

Cod. Sang. 1394, p. 15

Eleven incomplete leaves and eight small fragments are all that remain of this manuscript of the works of the Roman poet Virgil (70–19 BC). The codex containing the *Eclogues*, *Georgics* and *Aeneid* must originally have comprised about 340 pages. The wide margins of some fragments show that it was once a luxury manuscript. It was probably written in Rome in the fifth century. It is not clear when it arrived at St Gall. In around 1200, a few pages were overwritten with liturgical texts (known as a palimpsest). The sheets that survive today were used as bookbinding material in the fifteenth century.

The manuscript is one of only three codices in the world in capitalis quadrata. The other two – the so-called *Vergilius Augusteus* of seven leaves and a fragment on papyrus just eight lines long – have also been preserved only as fragments.

The script is named capitalis quadrata or 'Roman square capitals', because it consists of capital letters, most of which can be contained within a square, meaning that their width and height are approximately equal. It is adapted from Roman monumental inscriptions. This made it awkward for the scribe, as the quill had to be continually turned. So perhaps it is not altogether surprising that so few codices in this script have come down to us.

Although the shapes of the letters are familiar to us, the verses are not easy to read, because the words are written without spacing. Spaces between words appeared for the first time in the seventh century in Irish manuscripts (see p. 16).

Franziska Schnoor

EXCIPIVNT·STROPHADES·GRAIO·STANTE·NOMINE·DICTAE
INSVLAE·IONIO·IN·MAGNO·QVAS·DIRA·CAELENO
HARPYIAEQVE·COLVNT·ALIAE·PINHA·POSTQVAM
CLAVSA·DOMVS·MENSASQVE·METV·LIQVERE·PRIORES
TRISTIVS·HAVD·ILLIS·MONSTRVM·NEC·SEVIOR·VLLA
PESTIS·ET·IRA·DEVM·STYGIIS·SESE·EXTVLIT·VNDIS
VIRGINEI·VOLVCRVM·VVLTVS·FOEDISSIMA·VENTRIS
PROLVVIES·VNCAEQVE·MANVS·ET·PALLIDA·SEMPER
ORA·FAME
HVC·VBI·DELATI·PORTVS·INTRAVIMVS·ECCE
LAETA·BOVM·PASSIM·CAMPIS·ARMENTA·VIDEMVS
CAPRIGENVMQVE·PECVS·NVLLO·CVSTODE·PER·HERBAS
INRVIMVS·FERRO·ET·DIVOS·IPSVMQVE·VOCAMVS
IN·PARTEM·PRAEDAMQVE·IOVEM·TVM·LITORE·CVRVO
EXTRVIMVSQVE·TOROS·DAPIBVSQVE·EPVLAMVR·OPIMIS
AT·SVBITAE·HORRIFICO·LABSV·DE·MONTIBVS·ADSVNT
HARPYIAE·ET·MAGNIS·QVATIVNT·CLANGORIBVS·ALAS

quae lucescit in pri
mam sabbati uenit
maria magdalene
et altera maria uidere
sepulchrum et ecce
terrae motus factus
est magnus angelus
enim d(omi)ni descendit
de caelo et accedens
reuoluit lapidem
et sedebat super eum
erat autem aspectus
eius sicut fulgur et
uestimentum eius
sicut nix

ccl.. Prae timore autem
eius exterriti sunt
custodes et facti sunt
uelut mortui
respondens autem
angelus dixit mulie-
ribus nolite timere
scio enim quod ih(esu)m
ih(esu)m quae crucifixus

et qui cruci...
et hic surrexit
sicut dixit uenite
et ecce locum ubi posi...
quae d(omi)ni erat cito...
et ite et dicite discipul...
quia surrexit a...
et praecedet uos in...
ecce praedixi uobis
ccl.. et exierunt cito de...
in ccxxii numero cum timore
l ccxxiii et gaudio magno...
nuntiare...
discipulis eius
ccl.. et ecce ih(esu)s occurri...
illis dicens hauete
illae autem accesse-
runt et tenuerunt pe-
des eius et adorauer-
runt eum
tunc ait illis ih(esu)s noli
te timere ite nuntia
te fratribus meis ut

The oldest Vulgate Gospels – between scholarship and liturgy

Italy, 5th century

Cod. Sang. 1395, p. 132

THESE FRAGMENTS ORIGINATE FROM the oldest known manuscript in which the pure Vulgate text of the Gospels has been passed down. A total of 110 of its leaves have survived, most of which are held in the Abbey Library. Despite the gaps, it is one of the most important bases for the published text of the Vulgate Gospels.

The majority of the Vulgate goes back to the Father of the Church, St Jerome († 420). From 382 to 405 he corrected an existing Latin text of the Gospels and made new translations of many books of the Old Testament from Greek and Hebrew. The Vulgate was the standard text of the Bible in the Middle Ages.

This Gospel manuscript was written in Italy in the fifth century. The half-uncial script in which it is written is a Latin book script that uses the four-line system (i.e. with ascenders and descenders as seen in modern handwriting and fonts). Unlike the manuscripts that have come down to us from the Middle Ages, in this copy from the Roman period there are as yet no spaces between the words, nor any punctuation. Only paragraphs and their initial letters, which are a little larger and shifted to the left, serve to divide up the text.

Next to the columns of text there are details of parallel passages in the remaining Gospels, following the system of Eusebius. In the margins and between the lines there are also occasional critical and explanatory notes on the text dating from the fifth to sixth centuries. In Saint Matthew's Gospel, another, later entry indicates a part of the text that was to be read during the service on Easter night.

At some point in the Middle Ages, no later than around 1460, this Gospel manuscript was split up in the Abbey of St Gall and used as end leaves and spine linings in book bindings.

Philipp Lenz

The Gallus Bell

Ireland, *c.*600 (?)
Cathedral of St Gallen, by the Gallus altar, St Gallen Cathedral Treasury

A STONE'S THROW AWAY FROM THE ABBEY LIBRARY, in the former Abbey church, which is now the cathedral, slightly hidden by the choir screen to the right of the Gallus altar, is an unusual memento of the Irish mission to Lake Constance: the Gallus Bell.

We must ignore the clapper, the yoke, the arm and the baroque painting of Gallus with the bear and imagine the bell in its original form. The 33-centimetre-high body of the bell consists of two sheets of iron riveted together.

An inscription provides further information on its origin. According to this, Saint Gall used this bell in his cave in St Gallenstein near Bregenz, where he was living in around 610. In the baroque period it was thought to have magical powers. Documents in the Abbey Library provide evidence that it arrived in the Abbey of St Gall from the parish church of Bregenz in 1786.

The shape of this unusual object and the way it is made fit in well with the earliest Irish bell art, which even made its way into the languages of Europe through the Irish word 'clocc'. The use of sheet iron is substantiated in the writings of the early medieval scholar Walahfrid Strabo († 849) of Reichenau. In his life of Gallus, Walahfrid also specifically mentions the ringing of a bell during the monks' stay in Bregenz. It was used as a call to prayer.

Although we do not know for certain whether the bell actually goes back to Gallus or possibly to Columbanus, a connection to the early medieval Irish mission to the Lake Constance area can be assumed.

Cornel Dora

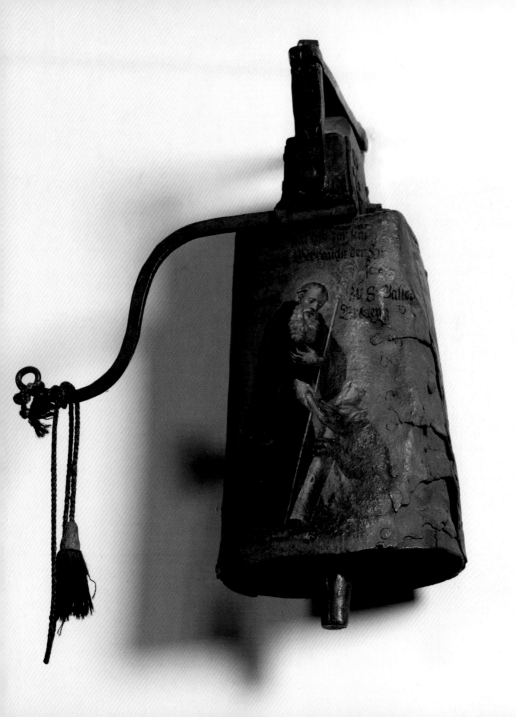

A fragment of an Irish manuscript

Ireland, 7th century

Cod. Sang. 1399a, Nr. 1, recto

THE DEVELOPMENT OF WRITING in Europe in the transitional period between Classical Antiquity and the Middle Ages was influenced by Irish monks. This is beautifully illustrated in this early Irish fragment from the seventh century.

The four small pieces of parchment were discovered in the late eighteenth and mid-twentieth century in the bindings of a number of books in the Abbey Library. They belong to the same page of a manuscript of the *Etymologies* of Isidore of Seville († 636) containing information on the human body, in this case, the head. The fragment is the oldest evidence of this important encyclopaedic work and one of the earliest attestations to the Irish culture of writing.

The calligraphy showcases a few important changes that can be linked to Irish scribes. They are probably to do with the fact that Latin was not a mother tongue in Ireland and there was therefore a greater need to support the understanding of the text through the appearance of the script.

Specifically, in the lowest section of the page beginning with *Aurium inde dictum est nomen a vocibus auriendis* (The name of the ear [*aures*] comes from the sucking up [*haurire*] of the voice), we can see the following: the start of the text at *Aurium* is marked by larger letters that diminish in a wedge shape, there are now small spaces between the words and, in addition, we find new types of punctuation marks, similar to commas, for dividing up the sentences. Most of these innovative measures have remained a part of our writing practice to this day.

Cornel Dora

The *Vocabularius sancti Galli* – Anglo-Saxon influence on the German language area

German-speaking area, 8th century

Cod. Sang. 913, p. 141

THE MANUSCRIPT THAT IS INCORRECTLY DESCRIBED as Saint Gall's Glossary is unusual in many respects. It is small and in a square format, the edges of the pages are irregular and there are many tears and holes in the sheets of parchment. Even the Anglo-Saxon half-uncial characters are unconventionally formed.

Besides biblical, theological and other texts, the manuscript contains two important glossaries or dictionaries. The first (pp. 139–45) is a glossary for the Latin biblical passage Leviticus 11:5–30. In it, uncommon animal names are paraphrased in Latin, given an Old English equivalent or explained using a combination of these two approaches. There is a particularly interesting comment by the learned Abbot Hadrian of Canterbury († 710), who preferred the Old English word *meu* (gull) for the Latin *larus* (seabird) rather than the Old English translation *hragra* (heron) that he found in the glossary.

At the end (pp. 181–206) is a Latin-Old High German glossary. It draws on three glossaries, one of which was organised thematically and the second alphabetically, while the third shed light on the meaning of a poem by Aldhelm of Malmesbury († *c.*709). The sources must have originated from England, possibly from the school of Canterbury.

The little book was written in the German-speaking area in the eighth century by a scribe trained in the Anglo-Saxon tradition. At that time, Anglo-Saxon monks and bishops were promoting the Christianisation of German language areas and their ecclesiastical organisation. The manuscript probably did not arrive at St Gall until later.

Philipp Lenz

uelut haebuc charæ olrion· opu
pam hupupa· uespertilioꝵm quel
deresle bruchus· similis
locus th maior attacus
igno opimachus igno
locus tot grer hoppae·
ptool- corco dilupbertia
influmi ne similis locesio
lux ecclecan th maiors tacut
homines manducat· migale igno·

Mbrogauis dheomodi hum
lir saenst moeti abbee fa
ter lih portey faet
abnuere ferlocuensi
Reuueye poeuhnen recusast
faeruuacz zeen refutaere
faertybaen absque uterge
uzzaenaemoaet scaeffi ab
sque aemicieiae uzzaenng fri
uhl scaeffi abinerubuum
anoesceopaendi abminn ih
ter anoelaez aiide absr
ferfi loigesu rumofi ab
eq freemist desir uuen
ist abdicat faerhuuidhre
abominaet faeruuaczzre de
nicaet faersechehre re
pudaet faerrybre abstru
hum lincafory deendsenu

The Abrogans Manuscript – the oldest German book

South-west German language area, 750/800

Cod. Sang. 911, p. 4

AS THE LANGUAGE OF THE CHURCH and of scholarship, Latin dominated the literature of the Early and High Middle Ages. That is why very little evidence of early writing in the vernacular has come down to us, mostly as single words between the lines or within the Latin text and more rarely in the form of longer translations or independent texts.

The Abbey Library houses a unique treasury of Old High German documents. Among these, the place of honour goes to the *Abrogans* Manuscript, because it passes on a particularly early and extensive corpus of Old High German. The first part of Cod. Sang. 911 (pp. 4–289) contains the Latin-Old High German *Abrogans* glossary of over three thousand Old High German words, from which the manuscript takes its name, and is structured by ornamental and figured initials. It is based on an alphabetical Latin-Latin dictionary that draws on older glossaries to the Latin Vulgate Bible, the individual words of which have been translated into Old High German. It begins with the Latin word *abrogans* (nullifying, humble) and its more familiar synonym *humilis* (humble), which are translated into Old High German by *dheomodi* (modern German: *demütig* = humble) and *samftmoati* (modern German: *sanftmütig* = meek). At the end of the manuscript (pp. 320–22), following a theological treatise, comes the oldest surviving Old High German version of the Lord's Prayer and the Creed, which have been translated word for word from the Latin.

The manuscript was written in the second half of the eighth century in an unknown monastery in the south-west of the German language area and it is not certain when it arrived at the Abbey of St Gall.

Philipp Lenz

The Irish Gospels of St Gall

Central Ireland, c.780

Cod. Sang. 51, p. 7

WITH FOUR COMPLETE IRISH CODICES and fragments of eleven other manuscripts, the Abbey Library of St Gallen owns the world's largest historical collection of early medieval Irish manuscripts. Irish monks who came on pilgrimage to the grave of their countryman Gall brought books with them as gifts for their hosts. Some, such as the Irish bishop Marcus and his nephew Moengal, who probably visited St Gall in around 850 on their way home from Rome, remained there forever, along with their books.

The Irish Gospels of St Gall is the most beautiful of the complete Irish manuscripts in the Abbey Library. On the basis of the calligraphy and the style of the illumination, it can be attributed to the period around 780 and a location in central Ireland.

Each of the gospels begins with a double page of illumination. The left-hand page depicts the Evangelist, while the text begins on the right-hand page with an illuminated initial that occupies almost the entire page. A carpet page, another illuminated initial and two whole-page depictions of the Crucifixion and the Last Judgement complete the decoration of the book.

The page illustrated here shows the beginning of verse 18 of the first chapter of St Matthew's Gospel with the words: *Christi autem generatio sic erat* (Now the birth of Jesus was on this wise). In the stems of the initial letters and in the frame, we find all the typical elements of Irish book illustration, which absorbed Celtic, Germanic and Mediterranean influences and combined them in a unique synthesis of spiral vortices, interlaced bands, intertwined animals, meanders and animal heads.

Franziska Schnoor

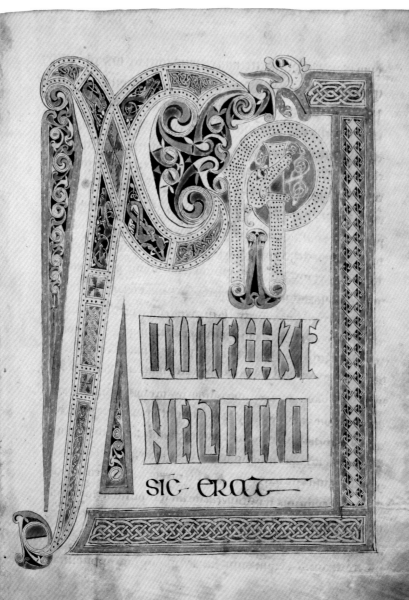

QUITIIKE
NEAOUO
sic erat

One of the oldest dated manuscripts in Switzerland –
the Wandalgarius Manuscript

Lyon (?), 793

Cod. Sang. 731, p. 234

THE CODEX SANGALLENSIS 731 stands out from the crowd of early medieval manuscripts because both the scribe, Wandalgarius, and the date of its completion, 1 November 793, were noted in it. It is the third oldest dated manuscript held in any Swiss library. It is thought to have originated in the Burgundy region, possibly at the Collegiate Church in Lyon.

The manuscript contains three collections of early medieval law, which are described as *Leges* or tribal laws. First there are extracts from the *Lex Romana Visigothorum*, i.e. the legal code issued early in the sixth century by Alaric II, King of the Visigoths, for the Roman part of the population. This is followed by the *Lex Salica*, a legal code of the Franks of approximately the same age, in which the Latin text has been infiltrated by a few Old Frankish vernacular terms. The last item is the *Lex Alamannorum*, the Law of the Alemanni, which dates from around 200 years later. The aim of the latter two tribal laws was often to direct conflicts along organised paths and settle damages suffered, such as manslaughter and theft, through the payment of compensation.

The manuscript is decorated with numerous initials depicting human forms and animals. A full-page illustration on p. 234 shows a man holding a staff in his right hand and a tablet or a book in his left. Below it are the words *Uandalgarius fecit hec* – 'Wandalgarius made this'.

Philipp Lenz

uicen dalgo niur p̄a lic

World maps as a view of the world

Chelles Abbey, *c.*800

Cod. Sang. 240, p. 189

THIS MANUSCRIPT IS ONE of a group of 29 manuscripts that have been linked by researchers to the Benedictine nunnery of Chelles (founded in 657/58) to the east of Paris. This collection is the earliest that we are certain was written by women. In the scriptorium the nuns also produced high-quality manuscripts for foreign abbeys. Two of them reached the Abbey of St Gall, including the one presented here, which was written around the year 800. At the time of its writing, Gisela, the sister of Charlemagne, was the abbess in charge of the convent (788–810).

At the end of the work *De natura rerum* by Isidore of Seville († 636) is a so-called 'T and O' world map, an early medieval schematic map of the earth. It is unfairly supposed that people in the Middle Ages were ignorant of geography. It was well known that the earth was a globe, and there was also an understanding of the arrangement of rivers, mountains, seas, lands, planets and constellations. However, in the T and O map, the actual appearance of the world was rearranged to match the biblical story of God's plan of salvation. The reference to eternity was more important than a detailed description.

This is clearly apparent in this depiction, which was finely drawn by an unknown nun using a compass. The three continents known at the time – Asia, Europe and Africa – and the ocean surrounding them are represented schematically. Asia is separated from Europe and Africa by the Nile, which is indicated by a double line, and Europe and Africa by the Mediterranean Sea.

Other versions of this map allot each continent to one of the three sons of Noah, who reclaimed possession of the earth after the Great Flood. Asia belonged to Shem, Africa to Ham and Europe to Japheth. However, the nun of Chelles has not included their names.

Cornel Dora

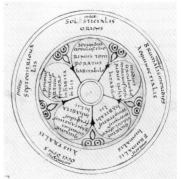

A decorative map representing the five zones of the world as a rosette (p. 134).

autem terrae mensuram geumǽrici centum octo-
ginta milium stadiorum ǽstimauerunt;

FINIT LIBER SCI ISIDORI

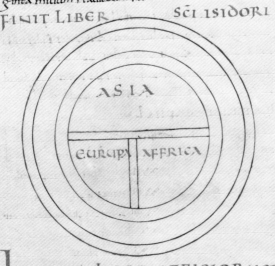

ASIA

EUROPA AFFRICA

INCIPIT LIBER OFFICIORUM

SCI ISIDORI

Dominomeo & diseruo florentio epo isidorus
eps. querisame originem officiorum
quorum maiesterio in ecclesiis erudimur.
ut quibus sit inuenta auctoribus. cognos-
cas indiciis. itaq: ueuoluisti libellum

IN PRINCIPIO
creauit ds caelum et terram.
Terra autem erat inanis
et uacua et tenebrae sup
faciem abyssi. et sps di fere
batur super aquas. Dixit
q di. fiat lux. Et facta e
lux. Et uidit ds lucem
quod esset bona et diuisit
lucem ac tenebras. Appel
lauitq; lucem diem et te
nebras noctem. factuq; e
uespere et mane. dies unus.
II Dixit quoq; ds.
fiat firmamentum
in medio aquarum.
et diuidat aquas ab aquis.
Et fecit ds firmamentum.
Diuisitq; aquas quae erant
sub firmamento ab his quae
erant super firmamentu. Et
factu e ita. Uocauitq; ds
firmamentum caelum. Et facta
e uespere et mane dies secun
dus. III Dixit uero ds. Congre
gentur aquae quae sub caelo
sunt in locum unum et appa
reat arida. factumq; e ita.
Et uocauit ds aridam terram.
Congregationesq; aquarum
appellauit maria. Et uidit
ds quod esset bonum et ait.
Germinet terra herbam uiren
tem et facientem semen et lignu
pomiferum faciens fructum iuxta genus
suum. cuius semen in semetipso sit sup
terram. Et factum e ita. Et protulit
terra herbam uirentem et ferentem
semen iuxta genus suum. Lignumq; fa
ciens fructum et habens unumquodq;
sementem secundum speciem suam. Et
uidit ds quod esset bonum. factumq; e
uespere et mane dies tertius. IIII Dixit
autem ds. fiant luminaria in firma
mento caeli et diuidant diem et nocte
et sint in signa et tempora et dies et annos.
et luceant in firmamento caeli et inlu
ment terram. Et factum e ita. fecitq;
ds duo magna luminaria. luminare

maius ut praeesset diei et luminare
minus ut praeesset nocti. et stellas.
Et posuit eas ds in firmamento caeli ut
lucerent super terram. et praeessent
diei ac nocti. et diuiderent lucem ac
tenebras. Et uidit ds quod esset bonu.
et factum e uespere et mane dies
quartus. V Dixit etiam ds. produ
cant aquae reptile animae uiuen
tis et uolatile super terram sub fir
mamento caeli. Creauitq; ds cete
grandia et omnem animam uiuente
atq; motabilem quam produxerant
aquae in species suas. Et uidit ds
quod esset bonum benedixit que eis dicens.
Crescite et multiplicamini et replete
aquas maris. Aues que multiplicentur
super terram. Et factum e uespere
et mane dies quintus. Dixit quoq; ds.
producat terra animam uiuentem
in genere suo. iumenta et reptilia
et bestias terrae secundum species suas.
factuq; e ita. Et fecit ds bestias terrae
iuxta species suas et iumenta et omne
reptile terrae in genere suo. Et uidit
ds quod esset bonum et ait. faciamus
hominem ad imaginem et similitudine
nostram. Et praesit piscibus maris et uola
tilibus caeli. et uniuersis animantibus
creaturae. Omniq; reptili quod mouet
in terra. Et creauit ds hominem ad ima
ginem suam. Ad imaginem di creauit illu
masculum et feminam creauit eos. Bene
dixitque illis ds et ait. Crescite et mul
tiplicamini et replete terram. et subi
cite eam et dominamini piscibus maris
et uolatilibus caeli. et uniuersis animan
tibus quae mouentur super terram.
Dixitq; ds. Ecce dedi uobis omnem
herbam afferentem semen sup terram.
et uniuersa ligna quae habent in se
metipsis sementem generis sui. Ut
sint uobis in escam et cunctis animan
tibus terrae. Omniq; uolucri caeli
et uniuersis quae mouentur in terra. et
in quibus e anima uiuens. ut habeant
ad uescendum. Et factum e ita. uidit
ds cuncta quae fecit. et erant ualde
bona. Et factum e uespere et mane
dies sextus. Igitur perfecti sunt caeli

210 sheep for a Bible – the Alcuin Bible

Abbey of St Martin, Tours, before 804

Cod. Sang. 75, p. 3

THE EXTERIOR DIMENSIONS of this one-volume Bible are already impressive. With a format of 55 × 40 centimetres and a weight of almost 20 kilograms it is one of the largest and heaviest manuscripts in the Abbey Library. The skins of 210 sheep were needed for its 420 leaves. However, other aspects of its creation are also worthy of note.

The manuscript was produced in the Abbey of St Martin in Tours, probably during the lifetime of Alcuin of York († 804). The great Anglo-Saxon scholar, who worked at the court of Charlemagne and was Abbot of St Martin in Tours from 796, had revised the Latin text of the Bible both grammatically and stylistically. Under his leadership Tours became a centre of Bible production. The monks copied around two Bibles per year – real mass production under early medieval conditions.

Extended characters at the end of a quire (p. 64).

Because the text was so long, the work was divided up. Up to 20 monks would be writing one Bible at the same time. Each one was given a quire, usually of four sheets of parchment, folded and inserted into one another, on which he had to copy his allotted section. No wonder the coordination did not always function one hundred per cent perfectly. Sometimes there would be text remaining at the end of the quire. Then the copyist would have to write the letters of the last lines very close together. At other times there would not be sufficient text to fill the parchment, so the scribe would stretch the letters at the end of the page as far apart as possible.

At St Gall the Alcuin Bible served as a work of reference, which was used by the monks as an aid to correcting the monastery's older Bible manuscripts.

Franziska Schnoor

The most important copy of the Rule of St Benedict

Abbey of St Gall, 800/30

Cod. Sang. 914, p. 52

THIS MANUSCRIPT IS ALMOST a holy object for monks and nuns of the Benedictine order, as it contains the most important surviving version of the Rule of St Benedict in relation to the history of the text. It is the oldest manuscript of the branch of provenance that leads directly back to Benedict of Nursia (*textus purus*).

A special feature of the manuscript is the critical comments on the text, which are noted in small writing in the margin. They list readings from the other branch of provenance (*textus interpolatus*), mostly orthographic variations, and do not originate from a modern user but were already included in the Reichenau exemplar, from which the St Gall Codex was copied. So, in a manner of speaking, we also have an early medieval critical edition of the text.

Nevertheless, it was not suitable for reading aloud to the monks during the daily Chapter meeting, as it is written in a type of Latin that was not standard in the Carolingian age. Instead it is closer to Benedict's original Latin than the linguistically simplified Carolingian manuscripts. It was probably used for intensive study of the text of the Rule, whereas a different manuscript (Cod. Sang. 915) was used for reading aloud every day.

Critical marginal note on the text: the *textus interpolatus* has *novembres* instead of *nobembres*.

In the early ninth century there was at least one more manuscript of the Rule of St Benedict in the Abbey of St Gall (Cod. Sang. 916). It is enriched by the addition of an Old High German translation between the lines, which helped the pupils in the Abbey school to understand the Rule while learning Latin at the same time.

Franziska Schnoor

: tuc:

liiſ diuinę auc do n tcc cif tcem
ue tenſ teſta mēn ta. quec no bi

: eorſ:

ſed & ex poſitioneſ earū. quę
a no mina tiſ. & or tho doxiſ catho
li ciſ pa tŋ b; fcc tę ſunl; poſt
haſ uero treſ lec tio neſcum

: hiſ ſuŋ:

reſpon ſon a a ſe quant ÷ reli
qui; ſex pſcl mi cū alle luia ccc
nen di; poſt hoſ lec tio apoſtoli
ſe qua tur ǂ cor de recitan dcc;

: litanię:

& uer ſuſ & ſup pli catio; lita nię

: kyrieleiſon:

idē; qŋe eleiſon; & ſic finian tur

x

uigilię noctnae; QVALITER AES
TA TIS TēPORE AGAT HOC I PALAVS

: uſñ:

¶ paſcha aū uſque ccd kalendaſ
no bem breſ omniſ ut ſupra
dic tum ē pſcl mo dię quanti
tcc ſ te ne at ex cepto quodlec

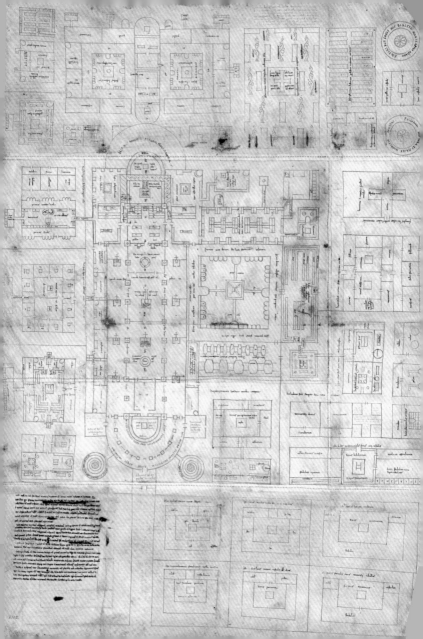

The Abbey Plan of St Gall

Reichenau Abbey, *c.*820/30

Cod. Sang. 1092, recto

'MY DEAREST SON GOZBERT, I am sending you this plan of the monastery buildings, sketched with a few strokes.' Thus begins the anonymous dedication accompanying this unique 'blueprint', which is ascribed to Abbot Haito († 836) of Reichenau Abbey. The plan was created under the direction of the Reichenau librarian Reginbert († 847), who worked on it together with a younger monk – as has been shown by analysis of the handwriting.

The drawing is of great importance for the history of early medieval culture and architecture, as nothing else exists that is of comparable significance. There are 45 buildings, including a large church, a school, rooms for monks and visitors, a facility for medical treatment, various workshops and barns, as well as six gardens of different kinds.

The physic garden (*herbularius*).

The plan is explained in detail with 334 Latin captions. It is for a Benedictine monastery with about one hundred monks and possibly the same number again of servants, pupils and guests. The drawing shows us what they needed in the way of architectural infrastructure and how this was organised.

This document has been arousing the interest of researchers for centuries. According to the current state of knowledge it is a design concept that was produced on the monastic island of Reichenau in order to help Abbot Gozbert of St Gall (Abbot 816–37) with the preparation of new monastery buildings. Built between 830 and 837, Gozbert's abbey church on the river Steinach actually became one of the largest north of the Alps. This is proved not only by excavations but also by the capitals, which are exhibited in the Vaulted Cellar of the Abbey Library.

Cornel Dora

Priscian's Grammar – Latin and Old Irish

Ireland, *c.*850

Cod. Sang. 904, p. 3

WITH THE CHRISTIANISATION OF IRELAND from the early fifth century the Latin language also arrived on the island. As Ireland had never been part of the Roman Empire, Latin was a foreign language that had to be learned from scratch. For this they used Latin grammar text books, including the extensive *Institutiones Grammaticae* of Priscian of Caesarea, which dated from the early sixth century.

A copy of the latter appears in Cod. Sang. 904. The two-column text of the large format book was written around 850 in Ireland, possibly in the monastery of Nendrum or Bangor. It was written by several scribes in Insular minuscule, with initials decorated with pen drawings. The majority of the 9,412 glosses in Insular minuscule were inserted between the lines and next to the columns of text in the same area and at the same time.

Over one third of the glosses are in Old Irish, making this manuscript one of the most important sources of information about this language. Among the entries are names of scribes, a short Old Irish poem alluding to a Viking raid, as well as Old Irish complaints about the effort of writing, such as 'Oh, my hand', 'I'm cold' and 'the ink is thin'. Special mention should be made of eight entries in the Ogham script, a writing system with characters made up of straight lines, which was used in the British Isles for inscriptions on stones during the first centuries after Christ. One of these entries alluding to excessive consumption of beer reads, 'Killed by beer'.

The addition of a hymn of praise to the Archbishop of Cologne, Gunthar (850–63), suggests that the manuscript from Ireland came first to Cologne before arriving at St Gall.

Philipp Lenz

The 'Death Song' of the Venerable Bede

Abbey of St Gall, *c.*850/70

Cod. Sang. 254, p. 253, left column, lines 6–11

IN THIS OLD ENGLISH VERSION of the 'Death Song' of the Venerable Bede in a manuscript written around 850/70, the Abbey Library owns one of the earliest and most authentic examples of the English language. Bede was the most important scholar of the Anglo-Saxons. Among other things, he was the first to use the Christian dating system throughout an entire historical work.

According to the account of his close friend Cuthbert, shortly before his death Bede spoke the following poem in Germanic long lines with alliteration instead of today's usual end rhymes:

Fore there neidfaerae naenig uuiurthit
thonc snottura than him tharf sie
to ymbhycggannae aer his hiniongae
huaet hist gastae godaes aeththa yflaes
aefter deothdaege doemid uueorthae.

(Before setting forth on that inevitable journey, nobody is so wise that it would not be necessary for him to consider – before his soul departs hence – what good or bad his soul will receive after its passing).

The St Gall version is the only one to give it in the Northumbrian dialect, which Bede himself would have spoken, as a monk from the northern English double monastery of Monkwearmouth-Jarrow. It must therefore be based on a uniquely reliable textual tradition.

The content of the text is a striking example of the philosophical change from the casual epicureanism of antiquity, as expressed, for example, in the *carpe diem* of the poet Horace, to the Christian view of life with its aim of achieving eternal salvation through a good and sinless life.

Cornel Dora

tura uniquib; nos a somno animę exsurgere precogitando ultimā horā
amonebat Et inirra quoq; lingua
ire erat doctus in nostris carminibus
dicens de teribili exitu animarum
ex corpore Fore thē neid faerae na
enig uui orchte thone snot tura
than him ꝥ hi sie to ymbhycggan
ne ær his hin longe huaet his gaste
godaes aeth tha yflaes aefter
deoth daege doe mid uueor thē
Cantabat ꝥꝯ antiphonas obnram consolationē Ꝫ sibi quarū unaest O rex
glorię dne uir tutū qui triū phator
hodie sup omne celos ascendisti ne de
relinquas nos orphanos sz; uertetis
ad̄ Cūuenis Ꝫ uit ad illud uer
bū ne dere linquas nos orphanos pro
rupit in lacrimas Ꝫ multū flebat
Et post horā cepit repetere que inco
auerat Ꝫ sic totachie faciebat Et nos
quidem audientes hec lacrimulas cum
illo Ꝫ Flemmus Altera uice legimus
altera plorauimus immo cū fletu le
gimus Intrala Ꝫ sic in quinquagesima

lesches usque ad diem prefatū deduxi
mus Et ille multū gauisus est Deo
gratias referebat quia sic meruisset
inhr mari Et se pdicebat flagella
d soms̄ hiliuique recipit Et senten
cia ambrosii Non sic uixer ut mepu
deat uit uiuere sz nec mori timeo
quia bonū dm habemus In ipsis aut
diebus duas opuscula memorię dig
na excepris leccionib; quas cotidie
accep; mus ab eo Sicantū psalmorū
facere studuit Id est a capite sci
euangelii iohannis usq; ad eū locum
in quo dicitr sed hec quid sunt intr
tantos In mam linguā ad utilitatē
ecclesię di conuer tit Et de libris sci
dore epi excerptiones quasdā dicens
nolo ut pueri mei mendacium legant
Et in hoc prcii obitu sine fructu labo
rent Cūuenis Ꝫ uit tertia feria
ante ascensionē dni cœpit uehe
mentius egrotare inhelitū Ꝫ mo
dicus tumor insuis perlib; appuruit
loca tamen illū die docebat Ꝫ hi
lar iter dictebat Ꝫ non num quam intr

Carolingian bindings – 1,000-year-old objects of everyday use

Abbey of St Gall, *c.*850/70 or shortly after

Cod. Sang. 254, Carolingian binding

MEDIEVAL AND EARLY MODERN manuscripts usually now have a binding with boards of wood or pasteboard, more rarely a covering of parchment or leather, which serve mainly to protect the bookblock but are also decorative. Over the centuries, the majority of original bindings have been replaced, because they were imperfect or no longer fulfilled new requirements for uniformity, aesthetics or functionality.

The Abbey Library boasts a unique and valuable collection of historical bindings that were produced using Carolingian, Romanesque or Gothic techniques. Of particular interest is the world's largest known collection of Carolingian bindings, which numbers 110 examples dating from the eighth to twelfth centuries. These bindings have survived for so long because the materials and sewing techniques are very robust.

The sheets of parchment were sewn quire by quire in herringbone pattern to cords that were pulled through channels bored in the front board. The loose ends of the cords were then threaded through similar channels in the back board and fixed in place with wooden wedges. The endbands were either unsupported, that is, sewn directly to the bookblock with link stitch, or supported, that is, sewn in herringbone pattern onto two cords that were anchored in the boards. Characteristic features are the heavy oak boards, the covering of chamois leather, the flat spine with protruding pieces of leather at top and bottom, the horizontal inscription on the leather of the spine and the clasps with eyelets that fastened over iron pegs inserted in the edge of the board.

Philipp Lenz

DI PETRVM
DIACO
NVM·DE
EBVS FIDE

DOMINI
CIS·SER
MO·BEATI
AVGVSTINI
EPISCOPI
DE SCA TRI
NITATE·
EX LIBRO
IPSIVS AD

Saint Augustine

Abbey of St Gall, 850/75

Cod. Sang. 433, p. 44

SAINT AUGUSTINE (354–430) was the most influential Christian thinker of the first millennium. The literary appeal of his inspired and humanely poignant work has lost nothing of its radiance even today. He was the author of timeless sayings such as 'Love, and do what you will' and 'What then is time? If no-one asks me, I know what it is; if I wish to explain it to him who asks, I do not know'.

Augustine was at first a teacher of rhetoric, lived quite a dissolute life for a fairly long time and became a father in 372. However, he also searched tirelessly for the meaning of life. Shaken by the experience of conversion on 15 August 386, he resolved to lead an ascetic Christian life; in 396 he became the Bishop of Hippo in North Africa and finally became the most important Doctor of the Church in his day and beyond.

Augustine was influenced by Plato, whom he describes in his major work *The City of God* as the most important pupil of Socrates. On the basis of Platonic teaching he developed an extensive system of Christian interpretation of the world which, more than any other, came to characterise the Middle Ages. Through Augustine, philosophy was transformed into theology and became the most important discipline of knowledge. This understands God as love and leaves room for a personal path through life. Among those influenced by Augustine was the reformer Martin Luther (1483–1546) who, as an Augustinian monk, was particularly indebted to him.

A beautiful pen drawing in Cod. Sang. 433 shows the Father of the Church dedicating a book to his Deacon Laurentius. It was created in 850/75 by an unknown monk of St Gall.

Cornel Dora

The oldest library catalogue of the Abbey of St Gall –
books with particular qualities

Abbey of St Gall, 850/75

Cod. Sang. 728, p. 4–5

APART FROM THE MANUSCRIPTS preserved in the Abbey Library, the lists of books are the most important sources for reconstructing the contents of the medieval library of the Abbey of St Gall. The oldest library catalogue dates from the third quarter of the ninth century and numerous supplements and corrections were added until the start of the tenth century.

The library catalogue contains 264 entries, with 395 individual books, and endeavours to organise the entries thematically. It begins (p. 5) with the books of the Bible, the Fathers of the Church and ecclesiastical authors, continues with monastic rules, lives of saints, ecclesiastical and secular law, glossaries, homilies, works on various subjects, and finishes with poetry, grammar and medicine.

Immediately preceding this library catalogue (p. 4) is a roughly contemporary shorter list of 30 books. It lists the books written in Insular, i.e. Irish or Anglo-Saxon, script. Almost all of these separately mentioned books have since been lost.

The two lists provide many references to the material form, age, lending, loss and entry of manuscripts. For instance, it was noted that a Reichenau manuscript was copied and then returned, that a martyrology was kept in the sacristy and a volume of the Old Testament in the monastery school, and that a number of books could no longer be found. In addition, quires of parchment and bindings were assessed as 'very old', 'tiny' or 'disintegrated', texts as 'useless', 'incorrect' or 'erroneous' and handwriting as 'very beautiful' or 'illegible'.

Philipp Lenz

LIBRI SCOTTICE SCRIPTI.

Metrum iuuenci. In uot.1. Epte pauli inuot1.
Act aptor. inuot.1. Epte canonge. vii. inuot.1.
Tractat bede in puerbia falom inuot.1. Ezechiel pp invot1
Euang. fcdm ioh. inuot.1. Enchiridion Aug. In uot.1.
Ite iuuenci metru Invot.1. Apocalypff. inuot 1.
Ite apocalypfif inuot 1. Metru fedul. inuot1.
De gradib. eclefiafticif. inuot.1. Arithmetica bo&ii vot.1.
Miffalif. inuot. Vita fci hilaru in codicillo.1.
Paffio f. martyru marcellii & petri.
Metru virg. inuot.1. Eiuf glofa In altero.
Libro.1. de inuentione corparif fci ftephi.
Quat.1. De relatione tranflationf fci galli. in nouo uolum.
Bede de arte m X. in qt.
Inftructio eclefiaftica ordinif. in codicello.1.
Lib.1. genefif. in qternonb.
Act aptor. & apocalypff. inuot.1. v&ern.
Quatrio.1. In nat innocencii legend.
Orationef & fententie varie inuot.1.
Orationef. in qternon.
Expofitio In cantica cant. In qtern. ii. Ite In reg. u qt. 1.

Bibliotheca. una. Eptatici. iii. an qd hif iob & tobiaf
Regum uolumina. ii. Salomonif uolum. v. id m
Libri omniu ppharum In uno uolumne. In uob. voluzb. alia diap. & dia fedicim
Item efaie & hieremiae In uno uolumne.
Ezechihelif & danihelif & xii ppha & N. In uno uot.

Paralippom. Iudith. Hefter. efdraf Machabe-
orum. In uno uolumne. Ite paralippom. Iudith. hefter. xd fiol. tobiaf
Item machabeoru uolumina. duo. In uot.1. ueteri.
Ite iob. tobiaf. iudith. hefter. ezraf neemaf. inuot.1.
Ite iob. tobiaf. iudith. hefter. inuot.1.
Ite iob. tobiaf. iud. hefter. invot.1. ite iob. inuot.1.
Tobiaf. iudith. hefter. In codice.1. advo tad.
ITEM DE LIBRIS NOUI TESTAMENTI.
Euangeliorum uolumina. iiii. & in uot. veteri. qhf duo non Inuen. fi.1.

Epiftolae pauli. & vii. epiftolae canonice & act. b&act
apoftoloru. atq; apocalipfif ioh apoft. Volum. v. aptof.
 & apocat.
Item euangelia. ii. fcdm ioh. fcottice fcripta inuot.1.

A Greek and Latin Evangeliary – Irish scholarship

Bobbio Abbey (?), 850/900

Cod. Sang. 48, p. 318

IN THE WESTERN EARLY MIDDLE AGES, knowledge of Greek (Ancient Greek) was rare and limited. This makes Cod. Sang. 48, which gives the Greek text of the four Gospels written in Greek majuscules, all the more significant. In addition, between the lines of text, in Insular minuscule, is an equally old, word-for-word Latin translation, which is sometimes expanded with grammatical notes. The text is divided up by larger initials with red and yellow infills. In the margins are references to the Eusebian Canon Tables and to parallel passages in the other Gospels, which simplify the study of the biblical text by making it easier for readers to find their way around it.

The script of the additional texts at the beginning and end of the manuscript points to Northern Italy. If we combine this conclusion with the Insular minuscule of the Latin translation, a possible place for the production of the manuscript appears to be the Irish-influenced Abbey of Bobbio, which was founded by the Irish Abbot Columbanus († 615). This would also fit in with the fact that, in the ninth century, Irish scholars played an important part in disseminating knowledge of the Greek language and Greek-Latin glossaries and texts in continental Europe.

The Gospels in St Gallen were part of a group that included two further Greek and Latin manuscripts of the same type, containing the Psalms and the Epistles of Saint Paul, which are held in other libraries. Cod. Sang. 48 is an important witness to the textual tradition of the Greek Bible.

Philipp Lenz

✝ EYAΓΓEΛION ✝ KATA ✝ IWANNHN

in principio erat *uerbum* *&* *uerbū qutmō erat ap*
EN APXH HN O ΛOΓOC. KAI O ΛOΓOC HN ПРOC TON

dm̄ *&* *d̄s erat* *uerbū* *hoc tic erat in principio ap*
ΘN. KAI ΘC HN O ΛOΓOC. OYTOC HN EN APXH ПРOCTON

dm̄ *omnia* *p ipsū* *facta st* *& sine* *ipso* *facta ÷*
ΘN. ПANTA ДIAYTOY EΓENETO KAI XWPIC AYTOY EΓENETO

nihil *quod factū* *in ipso* *uita erat* *&* *uita erat to*
OYДE EN O ΓEΓONEN EN AYTW ZWH HN KAI H ZWH HN TO

lux *hominū* *&* *lux* *in* *tenebris* *lucet*
ФWC TWN ANWN KAI TO ФWC EN TH CKOTIA ФAINEI

& *tenebris eā* *n̄ comprehendent* *fuit* *homo*
KAI H CKOTIA AYTO OY KATEΛABEN EΓENETO ANOC.

missus *a d̄o* *n̄e* *cui tit* *Iohannes* *hic*
AПECTAΛMENOC ПAPA ΘY O NOMA AYTW IWANNHC. OYTOC.

uenit *in testimoniū* *ut testimoniū p̄hibat de* *lumine*
HΛΘEN EIC MAPTYPIAN INA MAPTYPHCH ПEPI TOY ФWTOC

ut *omnes* *crederent* *p illū* *non erat ille*
INA ПANTEC ПICTEYCWCIN ДIAYTOY OYK HN EKEINOC.

lux *sed* *ut testimoniū p̄hibat de* *lumine* *erat*
TO ФWC AΛΛINA MAPTYPHCH ПEPI TOY ФWTOC HN TO

lux flumen *uera* *quē illuminat omne* *hominū* *uenien*
ФWC TO AΛHΘINON O ФWTIZEI ПANTA ANON EPXOME

tem *in* *mundū* *In* *mundo erat* *&* *mundus*
NON EIC TON KOCMON EN TW KOCMW HN KAI O KOCMOC

p eum factus ÷ *&* *mundus* *eum* *non cognouit*
ДIAYTOY EΓENETO KAI O KOCMOC AYTON OYK EΓNW

In *patria uenit* *&* *sui* *eum* *non receperunt*
EIC TA IДIA HΛΘEN KAI OI IДIOI AYTON OY ПAPEΛABON

quot̄ȳ ir receperunt *eum* *dedit* *eis* *potestate*
OCOI ДE EΛABON AYTON EДWKEN AYTOIC EZOYCIAN

filios d̄i *fieri* *his* *credentibus* *in* *n̄o*
TEKNA ΘY ΓENECΘAI TOIC ПICTEYOYCIN EIC TO ONOMA

eius *qui n̄* *ex sanguinibz* *neq;* *ex uoluntate*
AYTOY OI OYK EZ AIMATWN OYДE EK ΘEΛHMATOC.

carnis *neq; ex uoluntate* *uiri* *sed ex d̄o*
CAPKOC OYДE EK ΘEΛHMATOC ANДPOC AΛΛ EK ΘY

feh uur dom oof rat cen gebo huun hagal nod uf ger th perd

ᚠᚢ ᚾᚢ ᚦ ᚷᛟ ᚱ ᚻᚳ ᚾᚷ ᛈᚢᚢ ᛁᚾᛏ ᛁ ᛁᚷᛋ ᚷ ᚾᚷ

elux sigi ti borg eh man lagu ino tag odil ac aʃʃ ʃur aer

ᛉ ᛋ ᛏ ᛒ ᛗ ᚾ ᛖ ᛏ ᛗᚻ ᛏ ᛉᚱ ᚳᚱᚻᛏ

a a b c d d e f ʒ ʒ h ı kl m n o o p p

ᚳ ᚱ ᚳ ᚻ ᚦᛈ ᛗ ᛖᛉ ᚦᚻ ᚻ ᛁ ᛋ ᛏᚾ ᛏ � ᛈᛈ

q r ʃ ʃ t t u x z

ᛁ ᚱ ᛋ ᛋᛏ ᛏ ᚻ ᚾ ᚷᛏ

uſ runæ diſ quæ .i. læ procū ſcribuntur ita ueq̄ uotuſ uerſuſ ſit
primū breuiorib. .i. que ħ litera ſit inuerſū longioribuſ .l.
ſcribatur ita ut nom̄ corui ſcribat 𝑟 hiſ læ ita.
.i. ||||| · ||| · |||||||| · .i. ||||| · i. |||| · ||· |||·
lagoruna dicit quetia ſcribuntur p̄ .l. literā ut nom̄ corui

𝑟𝑟𝑟𝑟𝑟𝑟 𝑟𝑟𝑟 𝑟𝑟𝑟𝑟𝑟𝑟𝑟 𝑟· 𝑟𝑟𝑟𝑟 𝑟·𝑟𝑟 𝑟𝑟𝑟

hahal runa dicit iſte que infiniſtræ paſtæ quotuſ uerſuſ oſtendē
& indextera quotulē ipſiuſ uer ſuſſit ᛏᛏᛏᛏᛏ

ſtoofruna dicit que ſupra inpunctiſ quotuſ ſit uerſuſ ſubtiliter
oſtendunt ···|··· ······· ····|· ··|· ··||· ſed aliquando
mocem illuſ faciut ꝯ ſupra ſine puncta quiſæ ſiʒn. & ſub ordo uſuſ.
elofruna dicit que pulſæ officiat diſtinctaſ ꝗ̃ ſoniſ & litteriſ
ita ut primū incipiatur ap ſoniſ poſtea a litteriſ.

ΓΡΑΦΟ · ΓΡΑΦΗϹ · ΓΡΑΦΗ · ΓΡΑΦΟΜΗ ·
ΓΡΑΦΗΤΕ · ΓΡΑΦΟΥϹΗΝ ·

ʃacitaſ ſet dileatio aʃʃidecesſit int menosſe

Runes as a cipher

Abbey of St Gall, 850/900

Cod. Sang. 270, p. 52

RUNES ARE MYSTERIOUS CHARACTERS of Germanic origin. They were most widespread in Scandinavia and the British Isles and were used mainly for inscriptions on stones and objects, so one would hardly expect to find them in a manuscript from St Gall. Nevertheless, in Cod. Sang. 270 we find the Anglo-Saxon runic alphabet, which takes its name of Futhark from the first six characters (*feh, uur, dorn, oos, rat, cen*). It is written twice consecutively, firstly in the usual order of the runic alphabet. Above each rune is its name, with the corresponding letter of the Roman alphabet next to it. This is followed by a second list of runes in the order of the Roman alphabet.

Of course the monks of St Gall did not regularly write in runes, but the alphabet was well suited for use as a basis for ciphers. This page offers five guidelines, all of which follow the same principle: the runic alphabet is divided into three groups (two of nine characters and one of ten). Each rune is encoded with stems, branches or dots in a combination derived from the number of the group (I–III) and its position within the group (1–9/10). The process is illustrated using the word *corui* (= *corvi* – ravens), which produces the following combinations: I 6, III 8, I 5, I 2, II 3. For example in *isruna*, the first cipher, it is represented with long and short stems.

The page with the runic alphabet is in the middle of a manuscript of school texts. Maybe a teacher in the abbey school used it to make lessons more interesting for his pupils?

Franziska Schnoor

The Folchart Psalter – a miracle of illuminated initials

Abbey of St Gall, *c*.872/83

Cod. Sang. 23, p. 134–35

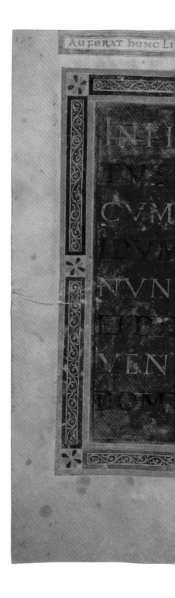

THE FOLCHART PSALTER, which was created between 872 and 883, is among the most splendid works produced in the St Gall scriptorium. It is named after the scribe Folchart († 903), who probably wrote and decorated all the 368 pages himself. With the initials of each of the 151 psalms, which look almost baroque in their variety and abundance, he succeeded in producing a masterpiece of medieval initial illumination.

Among the most beautiful in the entire history of art is the double page at the start of Psalm 51 (Psalm 52 in modern editions of the Bible). On the left is the introductory titulus in gold and silver on a purple ground: *In finem intellectus ipsi David...* (At the end, an insight of David). The frame consists of long rectangular fields with gold tendrils and squares with flowers in gold and silver; the latter appears dark because it has oxydised. On the opposite page is the beginning of the psalm: *Quid gloriaris in malitia* (Why boastest thou thyself in mischief). The Q in gold on a purple ground is made perfectly symmetrical by the repetition of the tail of the Q (cauda) on the left and the perfectly mirrored ornaments with tendrils and a total of eight dogs' heads. Behind the Q is a fine cross in pale blue and green. The frame is decorated with acanthus leaves.

Along the top margin Folchart placed a curse on thieves in elegiac distich: *Auferat hunc librum nullus hinc omne per aevum / Cum Gallo partem quisquis habere velit* (Let no man who wishes to enjoy salvation with Gallus ever steal this book from here.) The volume was probably one of the 13 books of Psalms that were to be found in the choir of the Abbey church in around 900, according to an account of Ekkehart IV († *c*.1060).

Cornel Dora

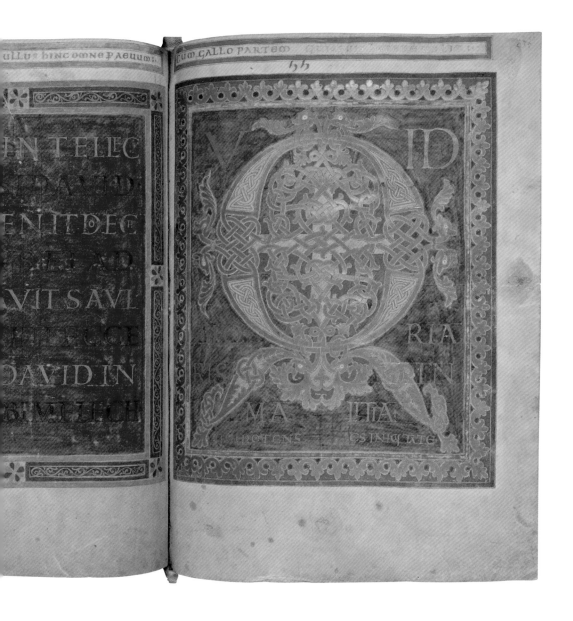

PSALMVS DAVID · CVM ESSET
IN DESERTO IDVMEAE ·

D͞S D͞S ME
US · AD TE DE LV
CE VIGILO
S ꞇIꞇIVIꞇ ꞇꞇ anima mea

quã multiplicꞇ ꞇibi caro mea ·

In ꞇerra deſerꞇa · ꞇ inuia · ꞇ inaquoſa

ſic in ſc̃o apparui ꞇibi uꞇ uiderẽ uirꞇuꞇẽ ꞇuã

The Golden Psalter – regal splendour and the worship of God

Completed in the Abbey of St Gall, 880/900

Cod. Sang. 22, p. 147

LIKE BOOKS OF GOSPELS, Psalters enjoyed a special status among medieval manuscripts because of their biblical origin and their importance for the liturgy. That is why they were often magnificently ornamented.

A good example of this is the Golden Psalter, which was completed in the last two decades of the ninth century. The large format, the spacious, single-column layout, the continuous use of gold ink for the texts of the psalms and the interspersed prayers, the wide spaces after the capital letters at the start of a line, the splendid initials and most of all the half and full-page figure drawings elevate this manuscript to an outstanding position.

At the beginning of the Psalter is an image of David, the Old Testament king and presumed author of the psalms, and another of Saint Jerome, who translated the psalms into Latin. These are followed by a dozen irregularly distributed pictures of scenes from the life of David, corresponding to the titles of the psalms next to them.

The page configuration, the script and the decoration of the manuscript are not uniform, as some aspects indicate West-Frankish origin, while others point to St Gall. The work was probably begun by West-Frankish scribes and illuminators before being largely completed by monks from St Gall. The intention may have been to display the magnificent psalter to high-ranking guests in the church on the occasion of royal visits.

Philipp Lenz

Labyrinthus Cnossia in Creta insula

The labyrinth as a path through life

Abbey of St Gall, 9th/10th century

Cod. Sang. 197, p. 122

PEOPLE IN THE EARLY MIDDLE AGES were no different from us in that they also wondered about the meaning and purpose of life. They were helped in this by the ancient image of the labyrinth, which was reinterpreted as an expression of Christian beliefs. Three manuscripts in the Abbey Library, dating from the ninth to eleventh century, contain drawings of labyrinths. They symbolise life as a pilgrimage and are precursors of the famous Labyrinth of Chartres from the early thirteenth century.

The message of the medieval labyrinth drawings differs from the understanding expressed in the Ancient Greek labyrinth, which literature has handed down to us as a prison and the path to the place of execution in the myth of the Minotaur. In the Christian labyrinth, the idea is transformed into a positive symbol. Here the path leads inwards to redemption. At the end it is not danger and doom that await us but God and eternal life, and you cannot get lost in its passageways because there are no branches.

In the Christian view the goal of human life was Paradise, which everyone hoped to enter after death. The fact that the pathway to heaven did not usually run straight was due to the imperfect nature of human beings. Nevertheless, the goal could be reached by all with the help of God, who had redeemed all humankind.

Thus the labyrinth became a vivid yet mysterious image of human life as a pilgrimage. It was found at many medieval places of pilgrimage and, having reached the goal of their journey, the faithful were thus able to follow their path once more and internalise it in concentrated form. This idea still exerts a fascination today.

Cornel Dora

The Evangelium Longum – an art work for the Liturgy

Abbey of St Gall, *c.*900

Cod. Sang. 53, front cover

No OTHER BOOK IN THE ABBEY LIBRARY unites so many varieties of artistic creation as the *Evangelium Longum*. This masterpiece was completed at the Abbey of St Gall in around 900.

Both the front and back of the binding are decorated with carved ivory panels in a frame of embossed sheet gold, and the front cover is also set with precious and imitation stones. In the centre of the ivory panel of the front is a depiction of Christ enthroned; at the centre of the back is the Virgin Mary and below her is a scene from the life of St Gall, his encounter with the bear.

This manuscript is an Evangelistary, i.e. a book with passages from the Gospels to be read during Mass in the order of the ecclesiastical year. It begins with a magnificent title and illuminated initial page with interlacing and small animal heads in gold, silver, orange and purple. The remainder of the text is structured by further interlace initials and display script.

In his history of the Abbey, the St Gall monk Ekkehart IV († *c.*1060) traces the creation of the Evangelistary back to an illustrious circle of people. For instance he describes the ivory panels as originally being the property of the Emperor Charlemagne and the Archbishop of Mainz Hatto I. Then he praises two St Gall monks, Tuotilo for the carving and goldsmith's work and Sintram for the beautiful calligraphy of the text, as well as Abbot Salomo of St Gall for commissioning the book and creating two of the initials. On the other hand, he makes no mention of Amata, a wealthy lady who contributed financially to the making of the book, whose name can be seen engraved on the binding and inscribed in the manuscript.

Philipp Lenz

Ivory panel on the back cover: A bear brings Gallus a log of firewood (left). In return, Gallus offers the bear a loaf of bread, while his companion sleeps on the ground (right).

At the top margin of the page, in gold ink, is the name of Amata, who, according to an engraving on the border of the back cover donated 12 denarii for the production of the book (p. 199).

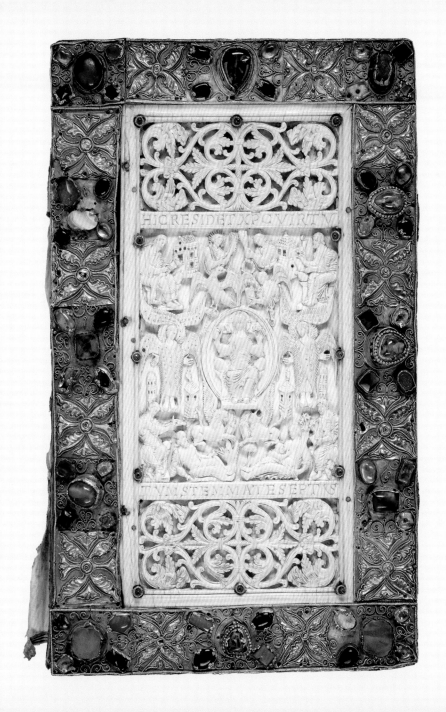

The Liturgy of the Hours in Neume notation –
the Hartker Antiphonary

St Gall, *c.*990/1000

Cod. Sang. 390, p. 13

THE HARTKER ANTIPHONARY IS THE oldest manuscript of the chants for the monks' Canonical Hours that is complete with musical notation known as neumes (the fine signs between the lines). It gets its name from Hartker († 1011), the St Gall monk and recluse who, from 980 to 1011, lived immured as an incluse in a cell in St Georgen above St Gallen.

The delicate neumes were written by five different people. Hartker may possibly have written the text and part of the neumes but collaborated with others on the musical notation. In any event, there must have been a number of monks at St Gall around the year 1000 who had mastered neumatic notation at this very high level.

The Antiphonary consists of two volumes, a winter section and a summer section. It contains a total of six whole-page images. Four of these depict important holy days in the ecclesiastical year: the Last Supper and the washing of the disciples' feet (Maundy Thursday), the Crucifixion (Good Friday) and the Empty Tomb (Easter Sunday).

At the start of the winter section there are two further illustrations. One is a dedicatory picture showing Hartker presenting his book to Saint Gall. The second is the earliest surviving representation of the inspiration of Pope Gregory the Great, after whom Gregorian Chant is named. The Holy Spirit in the form of a dove is perched on his shoulder, whispering the chants in his ear. Gregory dictates them to a scribe, who notes them down with a stylus on a wax tablet. If you look very closely, you can make out individual neumes on the wax tablet.

Franziska Schnoor

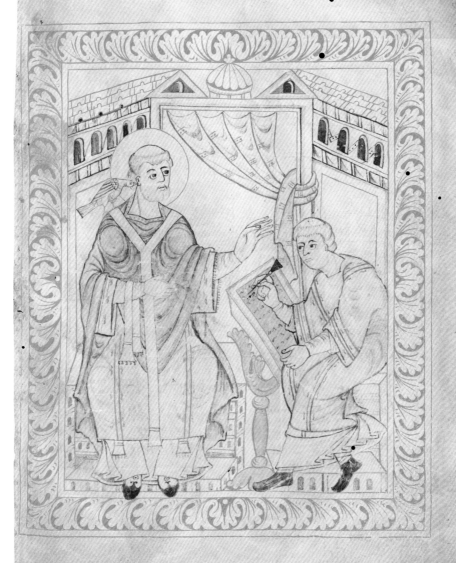

Pneumatis e̅ hic ros· ubi uult cadit· atq̕ rigat nos

ſal deE p̄ nertiaſ lapſiſ frigeſcere flammaſ

Aut uiſ puia· gemmarū ſit tibi dura

Da fęno ... purgatoriuſ ſigniſ

Fixa uel immota ... ſedo ſuaue

Eiuſ & in nolle non e̅ mutabile uelle

Si preco mutatur· hoc preſciuſipſe operatur

flectitur ergo uirū p̄ amore voce bonorū

... ſurienſ homini· ſitienſ q̕ piuſ miſerer

Sed q̕l mutauit· hocante ſciendo dicauit

Nil ... arbitriuſ uiſ offert aut dicatuſ

Qui priuſ ... & cuncta ſuendo dicauit

Speſ bona; mandatū nimiſin dulcedine latum

P qua n̄ motam· prece mutamuſ deritatem

Hęc ſpeſ cottidie· figatur ut anchora corde

Speſ hoſte ſenuum galeata repell in euum

Spe fidi ... ſuperat dilece ... cuncta

Speſ ... fauea ... que maior abhereſt

Benedictioneſ ad m̄ſaſ· Ymnon rabbani d ſco Gre

In the poet's study – an early medieval autograph of Ekkehart IV

Abbey of St Gall, *c.*1035/60

Cod. Sang. 393, p. 184

THIS SMALL-FORMAT MANUSCRIPT is a rare example of an early medieval autograph. In it, the St Gall monk Ekkehart IV († *c.*1060) wrote down and collected the poems he composed and made multiple revisions. This can be seen from the erasures, corrections and additions between and beside the lines of text and from the different colours of ink.

According to their titles, the majority of the poems were conceived as blessings for the lectors, the monks and pupils who read aloud to their fellows, and follow the order of the ecclesiastical year. However, they are interwoven with poems that Ekkehart is said to have composed as a schoolboy following the instructions of his teacher, Notker the German, noted down on sheets of parchment and later shown to his own pupils as example exercises.

They are followed by blessings of various foods and drinks, which name a whole host of types of bread and dairy products, varieties of fruits and vegetables, and kinds of meat, poultry and fish. Ekkehart IV drew this culinary knowledge directly or indirectly from the Bible, the *Etymologies* of Isidore of Seville and perhaps even from Virgil.

The manuscript concludes with verses for wall paintings planned for the cathedral of Mainz and the Abbey church of St Gall and a Latin translation of an Old High German song in praise of Saint Gall.

Although the poetry of Ekkehart IV is more an obligatory academic exercise than high poetic art, the use of internally-rhymed leonine hexameters with a caesura can nevertheless be considered innovative. Ekkehart's revisions were not necessarily intended to produce a final version but present alternative wordings and provide explanations.

Philipp Lenz

erunt stulti · hob pouma
bet sie daz dannan·daz ist naufragiu cedrorum nals dero

sinal fogele · hus · mere fogil · letro · antfrista
passerum·uuanda domus fulice ist iro dux·Anderiu editio

her fogil · meut · allen
chit·herodii domus dux e eorum·herodius ist maior omnium

fogelin
uolatilium·der uberuuindet den aren·unde izet in·unde be

machtigostun · herren
zeichenet potentes fortisimos·die ouh uuilon duont renun

auuers · auuerte
tatione seculi·unde busont inhimele·Daz pilde luchet ouh

dara andere die uueicheren sint·uuanda in iro zimberon li

keistliche · an tiefren · leron
chet· Montes excelsi ceruis·hohe berga·sin stat dien hirzen
S piritales sin beheftet in sublimioribus pceptis· Guleo aber hu

nemuore · riuuuige
miles unde penitentes·Vuaz sol iro trost sin· Petra refugium

stein · murmunton · ih meino sundigen
erinacus· Xpc ist petra·er si fluht erinatus·ide peccatoribus·

murmenti · ein tier · also michel · so der igil
Erinatius ist animal magnitudine ericii·daz chit des igelis·

in gelichenusse · perin · unde muse · mus · pergis
similitudine ursi & muris·daz heizen uuir murem montis·

in dien lochen · dero · alpon
uuanda iz in foraminibus alpium sina festi habet·steit luna

sina brut · in zite · dirro · todigi
in tempore· Er teta ecclam in tempore huius mortalitatis·in

dero si suinet unde uuahset also luna·si uber uuindet aber die

zit
unstatigi·so tempus zegat· Sol cognouit occasum suum Xpc

sunna rehtir
sol iustitie irchanda sinen tod·Vuaz ist daz· Er uuolta in er

licheta uno·er leid in gerno· Posuisti tenebras· Sament demo

uingeron
tode saztost du got finstri·daz teta er sinen diseplis uuanda sie do iro

spem ferluren·die sie an imo habeton· Et facta est nox· Vnde

hinaht · kerera
diu naht uuard do·fone dero Xpc ze petro chad· Hac no

din · der · uuider uuard · daz · er dih ruoson
CTE EXPETIVIT TES ATAHAS · VT CRIBRARET

also · uuerzze
TE SICVT TRITICVM· He skein daz·do er sin ze drin

malen ferlougenda· In ipsa pransibunt omnes bestie silue·

In dero naht farent uz in iro uueida alliu uualdtier alliu

The marmot in the Psalter of Notker the German

Einsiedeln Abbey, 12th century

Cod. Sang. 21, p. 384

THE ST GALL MONK NOTKER THE GERMAN († 1022) is considered to be the most important translator into Old High German. In order to make life easier for his pupils, he translated difficult works, for example Boethius' translation of Aristotle, from Latin into Old High German and wrote commentaries on them. He also made the Psalms more easily accessible in the same way.

This illustration is from the oldest surviving copy of Notker's Psalter, which was made in the twelfth century in the Abbey of Einsiedeln. It is notable for the clarity of its layout: the red ink of the verses of the Latin psalms clearly separates them from the translation and commentary.

In the commentary on Psalm 104, v. 18 on this page we find the first use of the Old High German word for 'marmot'. Translated into German, the verse reads: *Die hohen Berge sind für die Hirsche, die Felsen eine Zuflucht für die Igel.* This translates literally into English as 'The high mountains are a refuge for the deer, [and] the rocks for the hedgehogs', whereas the

King James Bible refers to the animals as 'wild goats' and 'conies'. Notker explains *erinatius*, literally 'hedgehog', as 'Animal the size of a hedgehog, similar to the bear and the mouse. We call this "Bergmaus" (literally "mountain mouse"), because it makes its home in the caves in the rocks of the Alps'. Above the line, *erinatius* is translated by *múrmenti* (modern German Murmeltier = marmot).

In the original Hebrew of the Psalms this refers to the hyrax, a rabbit-sized desert animal that looks like a cross between a guinea pig and a marmot. Of course, Notker did not have the Hebrew text before him, but instead he had a commentary by the Church Father Saint Jerome that described the exotic animal. In the marmot, Notker chose an animal that not only looks rather like the hyrax but also has a similar habitat – much more accurate than the Latin hedgehog.

Franziska Schnoor

The other side of history

Abbey of St Gall (?), 12th century

Cod. Sang. 897, pp. 60–61

'THROUGH A LECTURE THAT FOUND FAVOUR, I managed to get Symmachus, who was then Prefect [of Rome], to send me [to Milan]', writes St Augustine in his *Confessions* (Book 5).

Like Augustine, this prefect, whose full name was Quintus Aurelius Symmachus († 402/3), is one of the best documented personalities of antiquity. Famous as an outstanding orator, during his political career he held some of the highest offices of state. He was Proconsul of the Province of Africa from 373 to 374, Prefect of the City of Rome from 384 to 385 and Consul in 391.

Symmachus belonged to the non-Christian part of the population, which was diminishing in the fourth century. He endeavoured to preserve the cult of the Ancient Roman gods, for instance by opposing the removal of the altar of the goddess Victoria from the senate house in Rome.

His collection of letters, in this case a manuscript that may have been written at St Gall in the twelfth century, bears witness to his life in the highest circles of Roman society and his worry that the traditional religion will be lost, 'because the good will of the gods will be lost, if we do not preserve it through worship' (Book I, letter 46).

Symmachus was not only a contemporary of Augustine, but also of almost all of the Fathers of the Church who are portrayed on the ceiling of the Baroque Hall of the Abbey Library. He represents those who were not pleased by the rise of Christianity and reminds us that in history there are always losers as well as winners.

Cornel Dora

masse. Velle plura si tuo m̅ con
nul cautioe michi ne te sermo
Instituto q̅ meo. ea sce pono.
ta inre intelligis eo te inuidie
tu q̅si ame pauca scribi uelis
scrip

scripta facere. cu̅ t germans
ctur ubius uideret q̅m mes
lucro officia honesta q̅n ocia
Ergo neq̅ tacito op̅ e̅ ut honue
accepto. Neq̅ omia mandanda
aliqd adnarandu̅ relinq̅tur
capta. & su̅mas negocioꝝ q̅b
ti excep̅t Conuen̅ int public
i custodia ciuiu̅ publico obse
dece. Benignitas eni̅ sup̅iori
t amittu̅r Omia q̅ sup̅ sunt.
t indicii. cui indulgentis
opa legata e̅ Eductu̅ pncip u̅
de expediet. Statuas enȳ ex ce
ti acclamationib; quib ami
ut rideas. Plura desino. ne
tra de tertu amoris uidear in
 Imoari

S ilentii ñri ratio diuisa e̅ su̅ effect. Me impulit
 pontificalis officii cura. te baiani ocu negligen
tia. Neq̅ eni mih̅i reside fac̅ remissio animi. qua̅ occu
patio. Hec miru̅ si te illa oratore sibi uendicat̅. cu̅
ipsu̅ hannibale side certa sit bello inuictu̅ man̅ dedisse
capanie. i̅ ulli̅ cesi aut soli illecebra retentu̅ Aduenax
lucos euaserat. & suasa circe pocula. & tricl y̅nui semu
uolueru̅ puellariu̅ Heq̅ ego te pingues seriasagere
c̅tendo. Aut uirtute putosregisse deliciis. si du̅ t leges
scribis urbanaru̅ reru̅ fessus ingente animi solli
citudine domas. amiciciaru̅ minuia nullus exequeris.
qui̅ arripis stilu̅ ñri q̅ inte affectioni honore mutuu̅ facis
usi maius auctoritate pontificis experir. Multa nobis in
collegio deliberanda s. Quis t has induc̅ias publici mu
neris dederit. Senties uis sacerdotis. i̅ impleueris susamic
Et tibi publicis negotiis occupato. breues littere demiunt
fastidiu̅ lectionis & mei officii assiduitas qequit scriben
du̅ uidebat̅ exhaustt. Merito salutatione librata frugi
epl̅e necessario stru̅gor copendio. Alia e̅ eni prestatio a
moris. alia lingue ostentatio. Atq̅ ideo m̅ antiquior sit
obsequendi opa. q̅m loquendi copia. Si uidebim̅ habun
du̅ sedul̅i iudicemur.
S eu te i̅ fortunarii si meritoꝝ habere delectu̅ Romaii

An early version of the Decretum Gratiani – a turning point in legal history

Modena (?), *c.*1150

Cod. Sang. 673, p. 3

THE DECRETUM GRATIANI WAS a milestone in the development of law. This book gathered old laws together and structured and developed the subject matter using new methods. The core of the *Decretum Gratiani* comprises extracts from the Bible and the writings of the Church Fathers as well as decisions of councils and popes. These extracts were arranged on the basis of constructed legal cases (*Causae*) and questions (*Quaestiones*) and their inconsistencies were resolved by the *Dicta Gratiani* using the dialectic scholastic method. Thanks to its use in the universities, this private textbook achieved legal status and remained valid in the Catholic Church until 1918.

Cod. Sang. 673 has an outstanding place among the hundreds of manuscripts and printed copies of the *Decretum Gratiani*, because it is a unique early version. The manuscript was written and illuminated in around 1150 or shortly after that in northern or central Italy, possibly in Modena, not far from Bologna, the area where Gratian was teaching law in the late 1130s and 1140s.

The two-column text is clearly structured by beautiful painted initials as well as by headings, capitals and the numbering of the *Causae* and *Quaestiones* in red ink. Before each of Gratian's statements there is a paragraph mark. Isolated marginal notes bear witness to the earliest scholarly analysis of the *Decretum Gratiani* and to knowledge of Roman law.

Philipp Lenz

Cā t̃es q̃ la in ie
et trouisk̃ induc̃ co
st̃a. cū certa q̃
ru trispositoẽ.

Incipiūt t exserta
ex decretis San-
ctorum patrum.
LAICVS qdā litrat̃. con-
cubinā habebat. tādē
ea dimissa. ad sub-
diac. quolaū. Se-
m̃ uxore sibi ascuit. p̃ pauca ad
diac. ascḣd. Seq; i epm elect̃ ẽ.
Querit q̃ an nubint̃s p̃t uot̃
sit sepandi. Sedo. an si eubmā
hūīc. i epm sit ordinād? Te to-
utr̃ i sacro ordine tātu ostitu-
ẽ. elegñd̃ sit i epm. S̃ q̃ nu-
bīt̃es p̃t uotū n̄ sepaent̃. Aug̃
in libr̃o de bono miugali ait.
Qui dā nubent̃es p̃t uotū. asse-
r̃ adult̃i. ego aū dico q̃ q̃ui
ē peccāt q̃ tales diudit̃. Se thod̃r
Si tū uotū iuginitatis hñs ad
iuugit uxor̃i. p̃ ea n̄ dimit
tat uxore. sh ib; āui penitat̃.
Dāpnabile ē īgt̃ uo. Ser̃. u̇ ē ec ait
uet̃ib; n̄ solū nube. sh 7 utile. Jd ē c̃
Si nupsit u̇go. n̄ pec̃. Nulla io iuiua
uirgo q̃ sem̃l cultu diumo se nū
dicauit. hax̃ u̇ sig nupsit.
habebit dāpnatioē. qa p̃mā fid
irrita fec̃. Se mich. Femina q̃ p̃t
obtitū matū su̇ sacru udam sup
cap̃ su̇ ipositū. 7 sim̃x se s̃cmo
male sub eod̃ udamie ē. p̃ea uo
ad nupt̃ rediet̃. qa p̃ ypochri
sim ecclastica regla ŝ̃biae uolunt̃.
7 n̄ legitime i uoto suo p̃māsit.

penitūtia agat d̃ illusioē nefan-
da. aqid q̃ i̇ pop̃d̃ reuirat̃. Se ea
br̃i. diacoīb;. subdiac. lxxv. sp̃.
7 moach̃ eubmā hāe. seu
matimoiū īthe. penit̃ tēdicemd̃.
c̃teta q̃; matimoia ab h̃moi p̃so
m̃ diuiqi. 7 p̃ ad penit̃. debe re-
digi. iuxta scor̃ canonū diffi-
nitioē iudicam?. Distigam g̃.
q̃ uoint̃e alii solemnit̃. alii sim
plict̃. Si plict̃. q̃b; aug̃. 7 theo
dor̃ loquit̃. Solemnit̃. q̃b; p̃
uotū bndictioē i sectioe accedit̃.
7 p̃ortū religios̃. d̃ qb; alii. Om
q̃ ut ostisū ē p̃ bndictioē i secio
tioe nube n̄ lic;. sine uoto i temē
tie. ad subdiac. n̄ deb; admit-
ti. n̄ g̃. pet̃. diac se q̃. Illusa
ce subdiac. p̃ sumāt̃ epi. n̄ q̃ se ea
ste iuctura. p̃ mistit̃. qa ill̃e tḣ ad
mistiū altar̃i accede. n̄ cui ca
stit̃ȧ aū susceptū mistiū fu
eit̃ p̃bata. Se ex. c̃. arelatis̃i.

Assum̃ aliq̃ ad sacdotiū h̃
nuqia uicto i stitutū n̄
oportet̃. nisi fuit̃ p̃ missa i uisio.
P̃terea placuit̃. Se ex eod̃. i n̄
i̇ diceps̃ n̄ ordinēt̃ diacoes
miugati. n̄ q̃ p̃ usioe. i portio p̃ sit̃
se castitat̃e. Can̄ illa p̃o auctoi
zate. diac. iudat̃ p̃ mitti nug̃
iū. cū ad sacdotiū tiū miugat̃i ad
mitti p̃hibeat̃. Sh 7 seqūit̃. subdi
ac. p̃ mitti uidet̃. cū d̃ diac. sp̃a
lit̃ p̃cipiat̃. u̇ sine castitat̃e p̃ba
tioe. mmie ordinent̃. hoc 7

si fvrtese da ir pflagen.
ivnchfrowen ane bagen.
do nam ir wol mit zvhten war.
manech ivnchfrowe wol gevar.
Do gawan enbrizzen was.
ich sage iv alf kyot las.
dvrch herzenliche triwe.
hvp sich da grozIv riwe.
er spoh zer kvneginne.
frowe han ich sinne.
vnt sol mir got den lip bewaren.
so mvz ich dienstlicher varen.
vnt riterlich gemvre.
iwer wiplichen gvte.
ze dienste immer cheren.
wande ich chan sælde leren.
dax ir habt valsce an gesigt.
iwer pris fvr alle prise wigt.
gelvcke iwch mvze selden warn.
frowe ich wil vrlobes gern.
den gebt mir vn lat mich varn.
iwer zvht mvze iwern pris bewarn.
Ir waf sin dan selden leit.
do werden dvrch gesellecheit.
mit ir manech ivnchfrowe clar.
div kvnegin spoh an allen war.
het ir min genozzen mer.
min frode wære gein sorgen her.
nv moht iwer vride niht bezzer sin.
des gelober aber swenne ir lidet pin.
ob iwch vertreit riterschaft.
in riwebæren chymberf craft.
so wixxet min her gawan.
Des sol min herze pfluhte han.
e flvite odr ce gewinne.
div edele kvneginne.
Sehvite den gawanf mvnt.
der wart an freden vngesvnt.
dax er so gahef von ir reit.
ich wæne ex waf in beiden leit.
Sine knappen heten sich bedaht.
dax siniv orf waren btaht.
vf den hoff fvr den palas.
alda der linden state was.
och waren dem lantgven chomn.
sine gesellen svf han iohz vernomn.
der reit mit im vz fvr di stat.
Gawan in zvhteclichen bat.
dax er sich arbeite.
vnt sin gezoch im leite.
ce Bearosce dax ist Scervlet.
den svlen si selbe biten des.
geleitet ce Dianazdrvn.
da wont etslich Bertvn.

derse bringet an den herrn min.
oder an ginovern di kvnegin.
dax lobt im kyngrimvrsel.
vrlop nam der degen snel.
bringvliet wart gewapent san.
dax orf vn min her bawan.
er chviste sine mage div kindelin.
vn och di werden knappen sin.
nach dem brale im sicherheit gebot.
er reit al eine gein widers not.
vr ist. wem. wer sir ir.
ich wil inz herze din zv ir.
so gert ir zengem rvine.
waz denne belibe ich chvine.
in dringen soltv sezten chlagiz.
ich wil dir nv von wribir sagn.
ia sit irz fro aventivre.
wi vert der gehivre.
ich meine den werden parzifal.
den lvndrie nach dem biul.
mit vnsvren worten zagete.
da manech frowe chlagete.
dax niht wendech wart sin reise.
von artvse dem berteneise.
hvp er sich do wi vert er nv.
den selben mæren griset zv.
ob er an freden si verzagt.
oder hat er hohen pris belagt.
oder ob sin ganziv werdecheit.
ist beidiv lang vride breit.
oder ist si chvrz oder smal.
nv prvet vns di selben zal.
waz von sinen henden si gesehen.
hat er Olvnstalwesce sit gesehen.
vnt den svzen anfortas.
des herze do vil svfzech was.
dvrch iwer gvte gebt vns trost.
ob der von iamer si erlost.
lat horen vns div mære.
ob parcifal da wære.
Beidiv iwer herre vn och der min.
nv erlivhtet mir di fvre sin.
der svzen Herzeloyden barn.
wi hat Gahmvretel svn gewarn.
sit er von artvse reit.
ob er liep oder herceleit.
sit habe bezalt an strite.
habt er sich an die wite.
oder hat er sider sich verlegn.
sagt mir sine site vn al sin pflegn.
Hv tvt vns div aventivre bechant.
er habe erstrichen manech lant.
zorse vnt in schiffen vf den wach.
ex wære lant man oder mach.

The St Gallen Epics Manuscript – 'I wish to enter your heart'

South Tyrol/Salzburg (?), *c*.1260

Cod. Sang. 857, p. 124

THE ST GALLEN EPICS MANUSCRIPT (known also as Nibelung Manuscript B) was included in UNESCO's Memory of the World Register in 2009.

Besides the *Nibelungenlied* and other works, this most important manuscript of Middle High German epic poetry, created around 1260 in South Tyrol or in the Salzburg area, also notably contains the best surviving version of Wolfram von Eschenbach's *Parzival*. This epic poem, considered by many to be the most magnificent work of Middle High German literature, depicts the progress of the eponymous hero Parzival through countless adventures and tribulations, leading him from an ignorant child to the compassionate and forgiving king of the Grail, who eventually finds happiness.

'What I, Wolfram von Eschenbach, have related about Parzival…' (p. 562a).

Much in this work is of compelling force, for instance how the boy Parzival discovers a sense of yearning for the unknown in birdsong and asks his mother what God is, how at the sight of three drops of blood from a wild goose he is transported to a different level of awareness of his love for his wife and in between defeats two knights, how he is reprimanded on Good Friday for bearing arms and thus pursuing false values, or how, fearful of appearing impolite by asking needless questions, he at first fails to ask the suffering Fisher-King Anfortas what is the cause of his pain.

Passages of unique delicacy are also to be found. These include the conversation between the narrator and Lady Adventure beginning at the T on the page illustrated: 'Open up!' 'To whom? Who are you then?' 'I wish to enter your heart.' In the end, that is what this wonderful work is all about – it wishes to touch our hearts.

Cornel Dora

A manuscript from the possessions of Pope Nicholas V

Florence, *c.*1440

Cod. Sang. 850, p. 3

THIS VOLUME OF PHILOSOPHICAL works of the Ancient Roman orator and statesman Marcus Tullius Cicero (106–43 BC) once belonged to the future Pope Nicholas V (1397–1455, pope 1447–55), born Tommaso Parentucelli. This is revealed by the coat of arms with the four bearded male heads on the first page. Parentucelli adopted this coat of arms when he was elected Bishop of Bologna in 1444 as, not being of noble birth, he had no family coat of arms. When he became pope he changed his coat of arms again.

The decoration of the manuscript was probably by Bartolomeo Varnucci (born around 1412/13). In any event, in terms of art history, this codex fits into the period of Florence in the 1430s and 1440s. From 1439 to 1444 a council was held there, in which Parentucelli participated as secretary to one of the cardinals. He evidently used his stay in Florence to acquire manuscripts of texts by the Fathers of the Church and other authors.

This codex is the only manuscript in the Abbey Library in humanist minuscule. Italian humanists developed this script in the early fifteenth century. They based it on the Carolingian minuscule, as used in Italian codices of the eleventh and twelfth centuries. In turn, from 1460 on, humanist minuscule was used by the first book printers in Italy as a model for the characters of their typeface. Consequently many typefaces that are still common today go back indirectly to Carolingian minuscule.

Franziska Schnoor

Incipit Marci Tulli Ciceronis questionum
tusculanarum Liber primus

CVM DEFENSIONVM laboribus se-
natoriisq; muneribus aut oro aut mag-
na ex pte dem aliquando libatus reuuli
me brute te hortante maxi ad ea studia
q relicta mio remissa q ite longo interuallo
intermissa reuocaui. Et cum omis artium que ad rectam uiuendi ui-
am pertinerent ratio et disciplina studio sapie que philosophia dr co-
tineri hoc michi latinis litis illustrandum putaui no qa philosophia
grecis et litis ac doctorib percipi no posset: sed semp sentio iudicium fuit
oia nros aut inuenisse pse sapientius qa grecos aut accepta ab illis

fecisse meliora que qdem digna statuissent in qbs elaborarent. Nam
mores et istituta uite resq domesticas ac familiaris nos pfectoz me-
lius tuem et lautius requ pubrs maiores certe melioribus tepuerunt
et istitutis et legibus. Quid loquar de re militari in qua cum uirtu-
te nr multu ualuere tum plus etiam disciplina. Iam illa q natura no arte assecu-
secuti sunt neq cum grecia neq ulla cu gente sunt conferenda. Que
eis tanta grauitas que tanta constantia magnitudo ai pbitas fides q
tam excellens in omi genere uirtus in ullis fuit ut sit cum maioribus
nris coparanda. Doctrina grecia nos et omi litterarum genere supabat i
quo erat facile uincere n repugnantes nam cum ap grecos antiquissi-
mum e doctissi genus poetarum si qdem homerus fuit et hesiodus an-
te romam conditam archilochus regnante romulo Serius poeticam nos
accepimus. Annis fere cccc x post romam conditam liuius fabula de-
dit appio claudio ceci filio Marco tuditano consulib anno ante
natum ennium q fuit maior natu q plautus et neuius Sero g au tis
poete uel cogniti ul recepti qd e in originibus solorib ee iepulis
canere conuiuas ad tibiam de clarox hominum uirtutib honore in
huic cum n fuisse declarat oratio catonis in qua obiecit ut pbrii mar-
co nobiliori qd i supuinciam poetas duxisset. Duxerat autē consul
ille etoliam ut scim ennium. Quo minus honoris erat poetis eo mi-
nora studia fuere. Nec in si q magis ingenis inito ene extiterunt
n satis grecox glie responderunt. An censemus si fabio nobilissi-
mo hoi laudi datum ess qa pingerer. Non multos etiam ap nos futuros
policletos et parrhasios fuisse. Honos alit artes oes q incenduntur
ad studia glia iacent ea semp q ap quoscq iprobant. Summam q
rudinem grecia sita censebant in neruorum uocisq cantib igit et epa-
minondas princeps meo iudicio grecia is fidib preclare cecinisse dicit
Themistoclesq aliqis ante annos cum i epulis recusasset litam est

The lives of the St Gall saints in pictures

St. Gallen, 1451/60

Cod. Sang. 602, p. 377

THOSE WHO CANNOT READ NEED PICTURES. In the St Gallen Legendary, no fewer than 142 pictures illustrate the life stories of the St Gall saints Gall, Magnus, Otmar and Wiborada. The St Gallen citizen Conrad Sailer wrote the codex between 1451 and 1460 for the convent-like Beguine community of St George, founded around 1430 on a site above St Gallen. As the pious women probably had no command of Latin, he wrote the text in German. The pictures, which art-historical analysis suggests may be the work of three different book illustrators, made the lives of the saints accessible, even to those who could not read at all.

There were no models for these extensive cycles of pictures. The illustrations set the saints in the everyday world of the fifteenth century, so the Beguine nuns could identify with the persons depicted as they read and looked at the images.

The pictures also convey many interesting details of late medieval life. One example is the miracle of Wiborada depicted here. When a wall of the Church of St Magnus was breached, a large piece of masonry broke off and struck one of the workmen on the foot. After lighting a candle at the tomb of Wiborada, he was able to go back to work the next day feeling fit and cheerful. Numerous pieces of equipment can be seen on the building site in the picture – a barrel of mortar, scaffolding, a ladder and two different hoists.

Franziska Schnoor

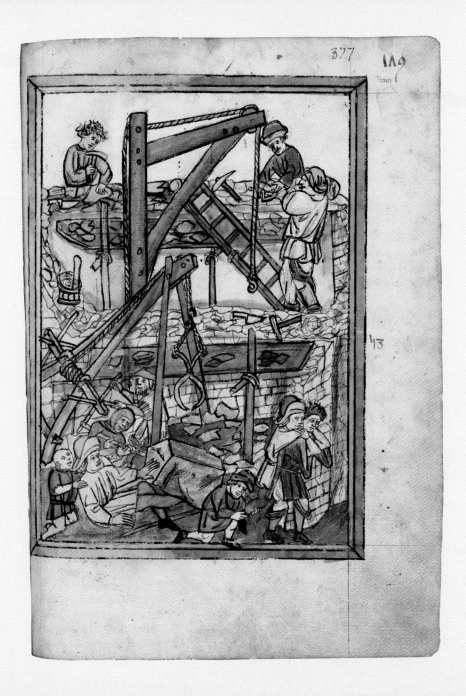

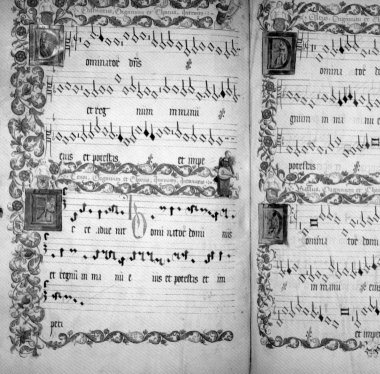

Polyphonic singing in the Abbey

Abbey of St Gall, 1562

Cod. Sang. 542, p. 362–63

THIS SPLENDID, GIGANTIC MANUSCRIPT (54 × 39.5 cm) is evidence of a blind alley in the musical history of the Abbey of St Gall. For many centuries the St Gall monks had sung exclusively in unison until, in the early 1560s, Prince-Abbot Diethelm Blarer (Abbot 1530–64) attempted to introduce polyphonic music for the most important festivals of the ecclesiastical year. At his behest, the Italian composer Manfred Barbarini Lupus wrote four-part vocal pieces for Mass and the Canonical Hours.

Barbarini Lupus based his compositions on the melodies of the Gregorian chant. The remaining three voices – soprano, alto and

bass – weave their way around the plain-song melody in the tenor. The whole choir sang from this one choir-book, which is the reason for its large size. All the same, the four-part works were not destined to enjoy success, despite the fact that one of the Abbey monks, Mauritius Enck, wrote an accompanying speech in defence of polyphony. The monks continued to prefer their accustomed plainsong.

The Lindau book illustrator Kaspar Härtli illuminated the main festivals with five whole-page miniatures and decorated the first double page of each festival with imaginative borders filled with birds, musicians and cherubs. Some of the double pages have depictions of instruments of the period. In the top right of p. 363 is a man with a tromba marina, a bowed instrument with a single string that makes a buzzing noise and sounds a little like a trumpet from a distance. This gives it an alternative German name meaning 'nuns' trumpet', while one of its English nicknames was 'nuns' fiddle'.

Franziska Schnoor

A globe as the spoils of war

Replica 2007–09 (original: 1571/76)
Baroque Hall of the Abbey Library

THE ST GALLEN GLOBE has an eventful history behind it. It came originally from Schwerin, where it was built by the geographer Tilemann Stella (1525–1589) at the behest of Duke John Albert I of Mecklenburg. The project came to a halt with the duke's death in 1576 and was only completed during the reign of his successor John VII. After the latter's death, the globe had to be sold in order to pay off debts. That is how this unique piece came to the Abbey of St Gall.

In the Toggenburg War of 1712–18, the last denominational war in the Switzerland region, the globe was seized as war booty by the Reformed troops from Bern and Zurich. Even after the Peace of Baden (1718), Zurich retained numerous manuscripts and printed books as well as the globe. This led to the so-called 'cultural assets dispute' in 2006. As part of the settlement of this dispute it was agreed the globe should remain in the Swiss National Museum in Zurich but the Canton of Zurich must produce an exact replica as a gift to the Abbey Library. It took over 7,000 working hours to complete and is illustrated here.

The St Gallen globe is both a terrestrial and celestial globe. While the maps of the heavens go back to woodcuts by Albrecht Dürer dating from 1515, the image of the earth is based on a map of the world by the famous cartographer Gerhard Mercator from 1569. The further you get from Europe, the more blank spaces there are on the map. Large parts of North and South America were unknown and you would search in vain for Australia and New Zealand, which had not yet been discovered.

Franziska Schnoor

A world traveller in the Abbey – Georg Franz Müller's travel diary

1669–82

Cod. Sang. 1311, p. 237

THIS ILLUSTRATED TRAVEL ACCOUNT is among the most interesting pieces of evidence of the contact between Europe and Southeast Asia in the seventeenth century. It was written by the Alsatian Georg Franz Müller (1646–1723), who served as a soldier in the Dutch East-India Company from 1669 to 1682. After an adventurous voyage from Amsterdam to Batavia (now Jakarta) via the Cape of Good Hope, Georg Franz Müller was stationed on various islands of the Indonesian Archipelago. During his time on Sumatra, Sulawesi and other islands, he kept a travel diary, in which he recorded people, flora and fauna in excellent drawings and sometimes rather halting verses.

After his return to Europe he became the personal servant of the St Gall monk Kolumban Andlau. Georg Franz Müller, who never married, was accorded lifelong board and lodging in the Abbey in return for the promise of bequeathing his estate to it. This included numerous travel souvenirs that he had brought home from Indonesia.

Of the original collection of 32 items, only five objects can be unmistakably identified today: a pair each of Chinese ladies' and men's shoes, a Chinese teapot in red porcelain, a Chinese purse and a small bast basket from the island of Sulawesi. Although the little basket seems unremarkable at first glance, it is in fact a great rarity. Very few everyday objects of this kind dating back to the seventeenth century have survived.

Small basket from the island of Sulawesi.

Franziska Schnoor

Ein Kakotoe

Ein Pingvin

Picca pis
Ein Fisch Specht

Saint Gall and his 'bookcase of the heart'

Grisaille painting by Josef Wannenmacher, *c*.1761/63
Baroque Hall of the Abbey Library, next to shelf EE

Without the Irishman Gall († *c*.640) who, together with his Abbot Columbanus of Bobbio († 615), came to Lake Constance as a missionary in around 612, settled by the river Steinach and founded a community of monks, neither St Gallen nor the Abbey Library would exist. Being an educated man he owned books, and the library can trace its origin back to these. In the baroque library, Josef Wannenmacher (1722–1780) depicted a scene from the early medieval life of St Gall by Walahfrid Strabo († 849), in which the study of manuscripts plays an important part.

Gall had only just begun his secluded life in the forest when he had to defend himself against being elected Bishop of Constance. In doing so he proposed that his place should be taken by Deacon Johannes, who came from the area and who did indeed eventually take over the position. However, before that, Gallus instructed him in Christian doctrine: 'So follow my advice, my son. Stay with me and read the books of divine knowledge and, by the grace of God, I will teach you to understand the scriptures.'

These lessons lasted three whole years, and books were of course part of it. The study and discussion of books was the method of teaching, so Walahfrid uses metaphors from the library in his portrayal of the scene. Bibles and Christian literature are a 'storeroom of the scriptures' (*celleraria scripturarum*) and Johannes entrusts the knowledge he has gained to his 'bookcase of the heart' (*armario cordis*). From outside to inside, into the heart – what a beautiful image, and a first echo of the idea of the healing place of the soul.

Cornel Dora

This edition © Scala Arts & Heritage Publishers Ltd, 2021
Text and images © Abbey Library of St Gallen

First published in 2021 by
Scala Arts & Heritage Publishers Ltd
305 Access House, 157 Acre Lane
London SW2 5UA, UK
www.scalapublishers.com

In association with the Abbey Library of St Gallen
www.stiftsbezirk.ch/en/stiftsbibliothek

ISBN: 978 1 78551 378 7

Project editor: Sandra Pisano (Scala Arts & Heritage Publishers Ltd)
Designer: Heather Bowen
Translation: Rae Walter in association with
First Edition Translations Ltd, Cambridge, UK
Printed in Turkey

10 9 8 7 6 5 4 3 2 1

Front cover:
The Q initial from the Folchart-Psalter,
Cod. Sang. 23, p. 135 (see pp. 48/49)

Front cover flap:
The Abbey Library of St Gallen

Frontispiece:
The Abbey Plan of St Gall, Cod. Sang. 1092
recto (see pp. 32/33)

Back cover:
Four-part mass chants by Manfred Barbarini
Lupus, Cod. Sang. 542, p. 362 (see pp. 72/73)